IMAGES
of America

DETROIT'S NEW CENTER

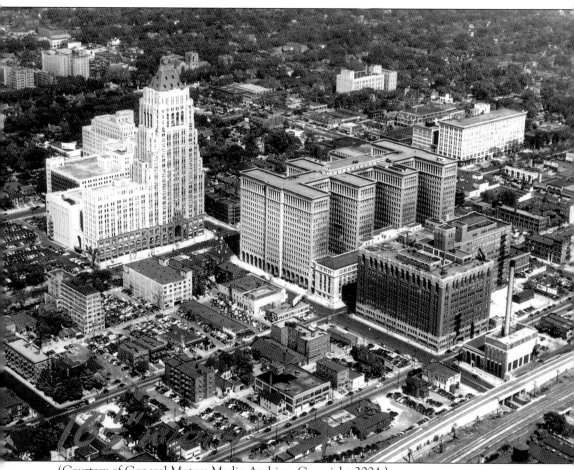

(Courtesy of General Motors Media Archive, Copyright 2004.)

IMAGES
of America

DETROIT'S
NEW CENTER

Randall Fogelman

ARCADIA

Published by Arcadia Publishing,
an imprint of Tempus Publishing, Inc.
Charleston SC, Chicago, Portsmouth NH,
San Francisco

Printed in Great Britain.

Library of Congress Catalog Card Number: 2004101699

For all general information contact Arcadia Publishing at:
Telephone 843-853-2070
Fax 843-853-0044
E-Mail sales@arcadiapublishing.com
For customer service and orders:
Toll-Free 1-888-313-2665

Visit us on the internet at http://www.arcadiapublishing.com

This book is dedicated to all Detroiters, native and transplanted, that struggle everyday to help this city live up to its potential. And to my father, for opening my eyes to the great possibilities that Detroit offers.

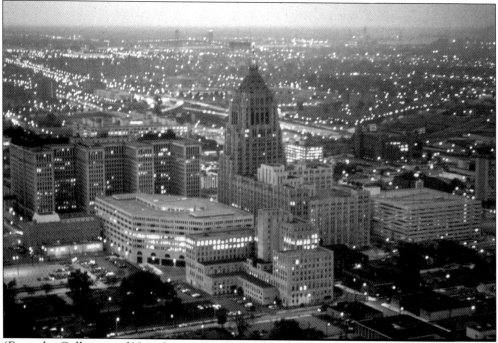

(From the Collection of New Center Council, Inc.)

CONTENTS

Acknowledgments 6

Introduction 7

1. Henry Ford Hospital and Health Care in New Center 9

2. General Motors Building and GM in New Center 21

3. Fisher Building and the Fisher Brothers 39

4. Albert Kahn and Albert Kahn Associates 49

5. New Amsterdam Historic District and
 the Early Auto Industry 57

6. Retail, Restaurants, and Hotels 67

7. Living in New Center 87

8. Music, Media, and Entertainment 101

9. TasteFest and Other Events 111

10. Recent Developments and Future Plans 123

ACKNOWLEDGMENTS

This book could not have been written without the support of Michael Solaka and the rest of the New Center Council staff, Sheryl Chambliss, Karen Gage, Edith Jouppi, and Greg Visee.

I am especially grateful to those who supplied images for this book: Susan Arneson and Kelly Ryan from Albert Kahn Associates Inc.; Dawn Eurich from the Burton Historical Collection; Mattie Majors from Detroit Public Schools; Judith Jackson, Linda Hill, and Dr. Gerald Smith from Detroit Youth Foundation; Robin Zohoury from the Farbman Group; Shannon Bergt Hulswit from Fineline Art Studio; Larry Kinsel from the General Motors Media Archive; Melanie Bazil and Riva Sayegh from Henry Ford Health Systems; William Springer Jr. and Dennis Zelazny from *New Center News*; Elizabeth Solaka for her wonderful photography; John Biggar from studioZONE; Jerry Burgess, Marge Bustillo, and Tom Matese from Trizec Real Estate Properties, LLC; Jackie Vaughn from Vaughn Marketing; Esteban Chavez; Mary Santos from WDVD; and Kenneth Josephson.

Thank you to those that provided information or opened doors for this project, including: Christopher Gorski and Gary Iott from Campbell-Ewald; Candace Butler, August Olivier, and Conrad Schwartz from General Motors; Tom Jepson, Chrystal Roberts, and Susan Schwandt from Health Alliance Plan; Robert Kwiatkowski from the Michigan Court of Appeals; Laura Kotsis from the National Automotive History Collection; Judy Adams from WDET; and friend to New Center Council, Dee Carter.

Thanks to Maura Brown from Arcadia Publishing for championing this book, and thank you to Amanda C. Quick for donating her time and expertise in proofreading and editing my text.

A special thank you goes to Pat Haller, former Vice President of New Center Council. If not for her dedication and hard work ensuring that the history of New Center was documented during her long tenure here, publishing this book would not have been possible.

Lastly, I must thank Darci A.P.G. Bryan for her patience while I worked on this very time-consuming project and for her unwavering support of my desire to be an "author."

INTRODUCTION

Detroit's New Center is a vibrant, diverse, and economically healthy district and the northern anchor of Detroit's Greater Downtown. The area is bounded by Virginia Park to the north, the Ford Freeway to the south, John R. to the east, and the Lodge Freeway to the west. What has grown into a wonderful neighborhood over the past 80 years began as the dream of a few visionaries and local businessmen. People like W.C. Durant, the Fisher brothers, and Albert Kahn built their dreams at what was, in the late 1910s, the outskirts of Detroit, and created a "new center" for the city. Although New Center has faced similar challenges to the rest of Detroit, it has weathered them with grace and is emerging again as one of the city's premier districts. This book is meant to chronicle New Center's proud history, its curent growth, and its bright future.

In the early 1920s, Detroit's automobile production began to boom. The industry was on the move, and the automobile was fast becoming the vehicle that would transform Detroit from a small industrial town to the "automotive capital of the world" and a true industrial powerhouse. This rapid economic growth created a shortage of land in downtown Detroit suitable to build a headquarters for a rapidly growing General Motors. When W.C. Durant concluded his search for the appropriate parcel on which to build his dream headquarters (originally to be known as the Durant Building), he settled for a spot on West Grand Boulevard, just one block west of Woodward Avenue. Here, Durant would build the largest office building of its day.

The Fisher brothers followed Durant to the area. When planning for their new office building, they, too were kept confronted by the same crowded conditions that GM had found in the downtown business district. They decided on a spot across from the Durant Building. One could speculate that the Fisher brothers selected the location for their building because they saw in the area an opportunity to create something new, leave a lasting impact, and build their dream of a "new center of commerce" in Detroit.

The brothers began with an almost blank slate. They were not confined to the plans and building styles developed in earlier times which filled the existing downtown. In New Center, they could create their vision of what a "downtown" could be. The area offered a unique opportunity for the Fisher brothers and in New Center they proceeded to turn their dreams into reality.

When the Fisher Building was completed, the brothers built the New Center Building. Owing to financial restrictions during the Great Depression, World War II, and the Korean War, plans for additional buildings were suspended. Fortunately, others stepped up and created substantial commercial and residential additions to the neighborhood, building on the contributions by the Fisher brothers, but none more so than General Motors.

For over 70 years, New Center served as the "corporate campus" for GM. GM was an exemplary corporate citizen and caretaker of New Center. The company built buildings, renovated historic homes, and funded organizations dedicated to the betterment of New Center. When GM decided to move their world headquarters to the Renaissance Center in the mid-1990s, a grand era came to an end. As this book is being written, a new era is underway.

General Motors could be considered the proud parent of New Center—under its watchful eye, New Center grew up. By laying the ground work, investing in the future, and providing the tools necessary for

continued growth and stability, GM raised New Center from infancy to young adulthood. Now all grown up, New Center is ready to go it alone. The rich history of New Center, which reflects the investment of and nurturing by GM, the Fisher brothers, and others, should never be forgotten—and, in fact, this history is the foundation for most people currently engaged in creating a new life for this unique district.

Looking after this special neighborhood and serving as official caretakers since 1967 is the New Center Council. New Center Council, Inc. (NCC) is the proactive leadership organization for New Center, engaging its Board of Directors, civic and community leaders, and government officials in initiatives that keep this one of the region's finest office, retail, and residential centers. The Board of Directors of New Center Council consists of stakeholders in New Center—including area businesses, non-profit, and health care leaders, community activists, retail store owners, building owners, homeowners, and others concerned with the general welfare of this special district. This is the group that will carry on the strong tradition of excellence in New Center.

New Center is a neighborhood rich in tradition. It is home to established businesses such as Detroit Hardware, WJR, and Dittrich Furs, and new businesses like Cuisine, Pure Detroit, and Biz-R Collection. New Center is new lofts in old buildings and old homes next to new townhomes. New Center is old friends living next to new friends, coming together for the common purpose of making this the best neighborhood in Detroit.

In New Center, we are greatly indebted to the district's creators for leaving such an unmatched architectural legacy to build upon. They created landmark buildings that could not be replicated today at any cost. They also created an ethic of pride in the neighborhood's well-being. This reverence for the past, combined with this community's dream for a bright future, bodes well for the future of New Center as it proudly marches towards its second century. In the following pages, I have attempted to give you, the reader, the whole story by including as much information about the present and the future as I have for the past. I hope you enjoy reading about New Center as much as I enjoyed writing about it.

Randall Fogelman
New Center Council, Inc.
Spring 2004

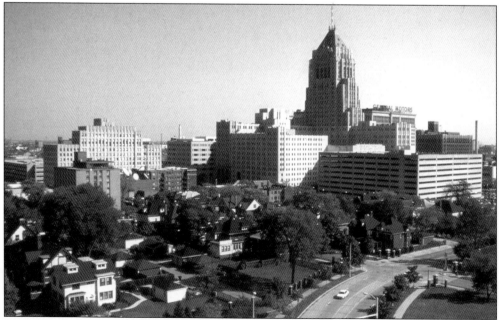

(From the Collection of New Center Council, Inc.)

One
HENRY FORD HOSPITAL AND HEALTH CARE IN NEW CENTER

Auto pioneer Henry Ford bailed out the struggling Detroit General Hospital and acquired sole ownership of the land and existing buildings in 1915. As he did with the automobile, Ford set about to create the best and most modern hospital, by using only the most state-of-the-art technology, methods, and techniques available. Since its founding, Henry Ford Hospital has grown from a 48-bed facility to one of the nation's leading integrated health care systems. In addition, because of the hospital's location, many doctors choose to have individual practices in New Center and it is also home to two of the state's major HMOs.

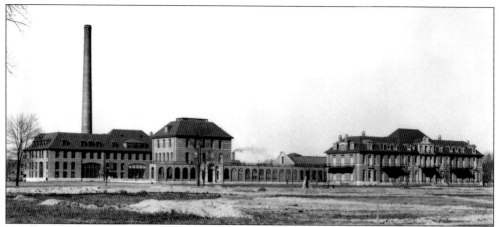

HENRY FORD HOSPITAL c. 1915. Financed and built by the auto baron, Henry Ford Hospital opened on October 1, 1915, with 48 beds. The original complex was made up of the patient building and other smaller buildings that housed the surgical pavilion, research quarters, kitchen, garage, and laundry. (Courtesy of the Lam Archives, Detroit, Michigan.)

HENRY FORD HOSPITAL GROUNDBREAKING. In 1917, Henry Ford's right-hand man, Ernest Liebold, was given the task of building a new patient building on the grounds of the hospital. He picked Ford Motor Company architect Albert Wood for the job. Together the two men traveled the country visiting hospitals as research for their hospital. Later in 1917, the cornerstone was laid for what would become the new Henry Ford Hospital. (Courtesy of the Lam Archives, Detroit, Michigan.)

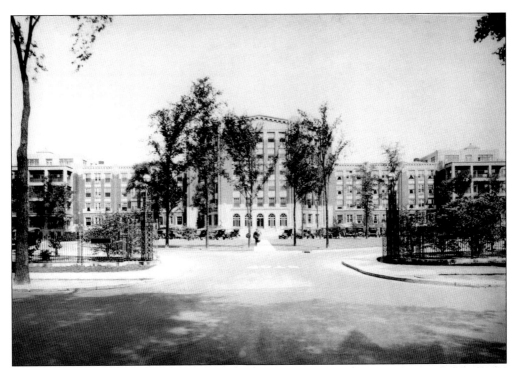

HENRY FORD HOSPITAL c. 1923. In 1921 the new 50,000-square-foot Henry Ford Hospital building opened. This new building, with 500 beds, was quite advanced for the day. The center tower of the building was six stories high and housed hospital administration. The patients were housed in four different four-story wings. (Courtesy of the Lam Archives, Detroit, Michigan.)

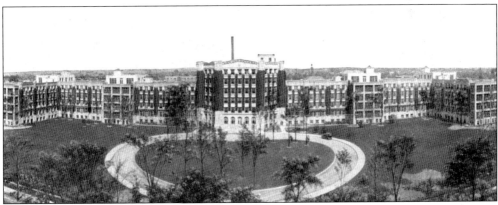

HENRY FORD HOSPITAL c. 1923. At the time, fresh air was considered an important part of the healing process. The new Henry Ford Hospital featured 40 porches with doors wide enough so that a hospital bed could be moved to the porch. There was also a rooftop garden that extended across the entire 750 feet of the roof. (Courtesy of the Burton Historical Collection, Detroit Public Library.)

11

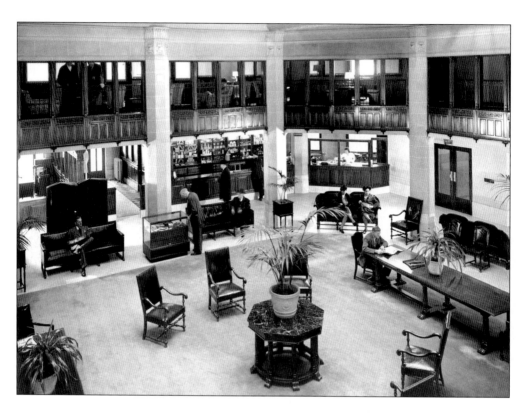

HENRY FORD HOSPITAL LOBBY. Henry Ford wanted his hospital to be a "hotel for sick people" and that was no more evident than in the lobby. The lobby was finished with wood paneling and a skylight featuring imported glass. (Both photos courtesy of the Lam Archives, Detroit, Michigan.)

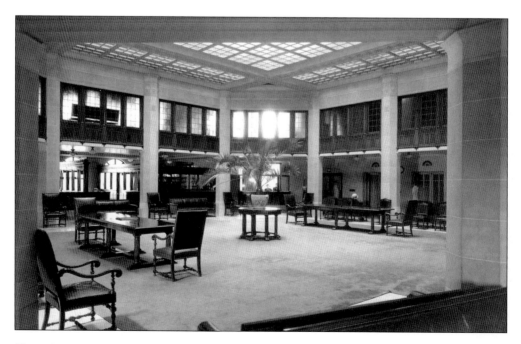

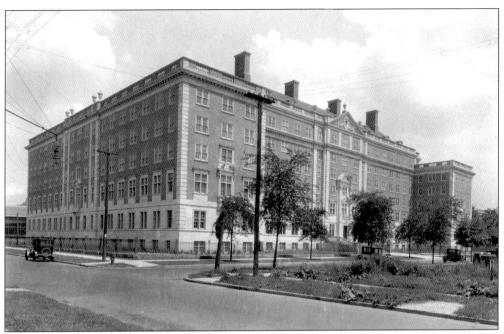

CLARA FORD NURSES HOME. In 1925, Henry Ford Hospital opened the Henry Ford Hospital School of Nursing and Hygiene. To house the new students, the Clara Ford Nurses Home was built on the grounds of the hospital. The building was designed by architect Albert Kahn. (Courtesy of Albert Kahn Associates, Inc.)

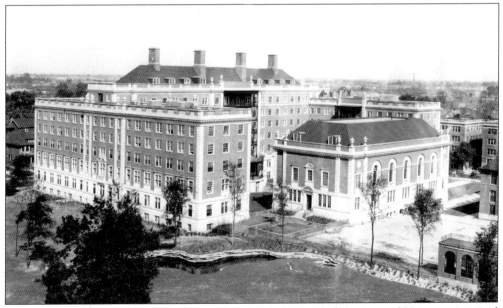

CLARA FORD NURSES HOME. The Henry Ford Hospital School of Nursing and Hygiene contained two buildings: the Clara Ford Nurses Home and the Education Building. They were connected by an underground walkway. Both designed by architect Albert Kahn, all finishes were selected under the supervision of Clara Ford, wife of Henry Ford. (Courtesy of Albert Kahn Associates, Inc.)

HENRY FORD HOSPITAL CLINIC BUILDING RISING. A shortage of space and a growing population in Detroit brought about the need for an even larger building. Ground was broken on a new 17-story clinic building in 1952. Progress on construction could be witnessed from the nearby General Motors Building. (Courtesy of General Motors Media Archive, Copyright 2004.)

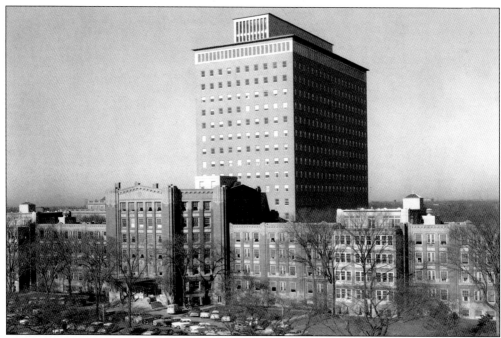

HENRY FORD HOSPITAL c. 1955. The year 1955 brought about the formal opening of the new clinic building which housed 14 specialty outpatient clinics, a medical library, and 20 new operating rooms. (Courtesy of the Lam Archives, Detroit, Michigan.)

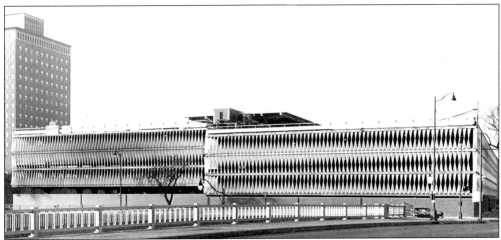

HENRY FORD HOSPITAL PARKING STRUCTURE. In 1959, a new 850-car parking structure, designed by Albert Kahn Associates, was built. The design, featuring twisted concrete panels, won an Excellent Design Award from the Detroit Chapter of the American Institute of Architects in 1960. In 1965 the General Service Building was added, and in 1968 an additional 900-car garage was built in the same award-winning style as the first structure. (Courtesy of the Burton Historical Collection, Detroit Public Library.)

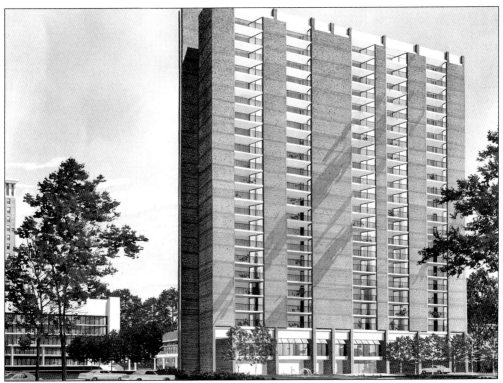

HENRY FORD HOSPITAL APARTMENTS. Designed by Albert Kahn Associates, Henry Ford Hospital Apartments opened in 1976. The 20-story building features 190 apartments and became the home for many of the hospital staff and residents. (From the Collection of New Center Council, Inc.)

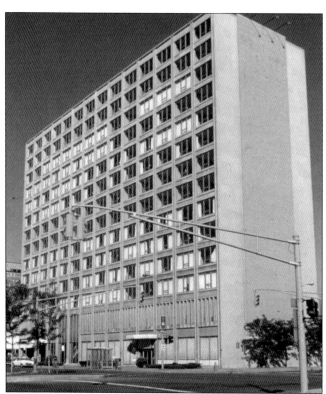

NEW CENTER PAVILION. The former Howard Johnson's Motor Lodge at West Grand Boulevard and Second Avenue was acquired by Henry Ford Hospital in 1978 and renamed the New Center Pavilion. The building provided much-needed space for the hospital and became home to the Henry Ford Hospital School of Nursing, the Sleep Disorder Center, and Hospice, among others. The building was imploded in 1997 to make room for additional parking. (From the Collection of New Center Council, Inc.)

ONE FORD PLACE. Henry Ford Health Systems bought the former Burroughs/Unisys Headquarters Building in 1992. Renamed One Ford Place, the building, located just across the Lodge Freeway from the main hospital, became the home of the hospital's corporate and administrative offices and provided much-needed space for research. (From the Collection of New Center Council, Inc.)

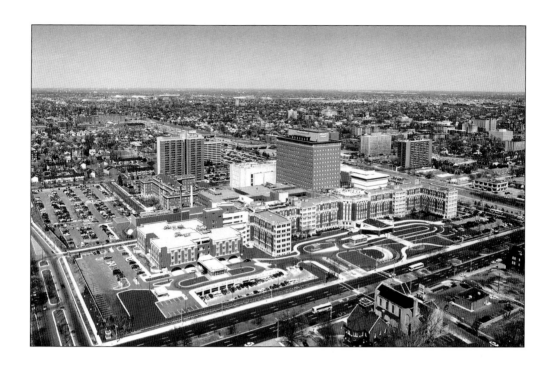

HENRY FORD HOSPITAL c. 2003. In 2004, Henry Ford Health Systems was ranked as the top integrated health care system in Michigan by Verispan, a Pennsylvania-based research firm. It is Michigan's sixth largest employer with more than 12,600 full-time employees. Almost 65,000 patients are admitted to Henry Ford hospitals each year. (Both photos courtesy of the Lam Archives, Detroit, Michigan.)

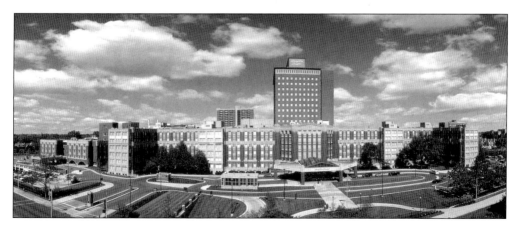

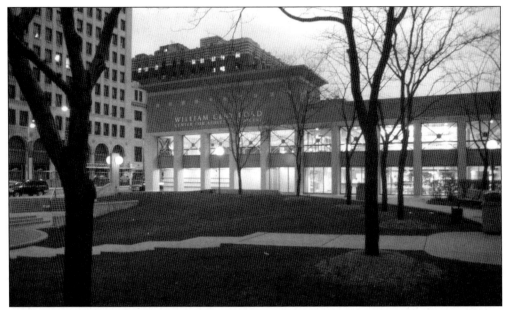

FITNESSWORKS. A joint venture between Henry Ford Health System and General Motors Corporation, the William Clay Ford Center for Athletic Medicine opened its doors in 1996. Located across the street from the Fisher Building, the building houses a health club (FitnessWorks) and HFHS's Center for Athletic Medicine, as well as HFHS's programs for industrial and cardiac rehabilitation. (From the Collection of New Center Council, Inc.)

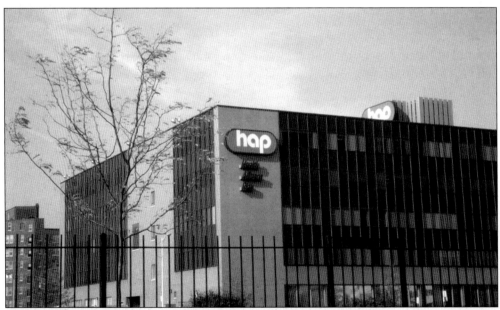

HEALTH ALLIANCE PLAN. Health Alliance Plan (HAP) is one of Michigan's oldest and largest health maintenance organizations. HAP moved into their Corporate Office Building, the former McCord Building on West Grand Boulevard, near Henry Ford Hospital, in 1978. (From the Collection of New Center Council, Inc.)

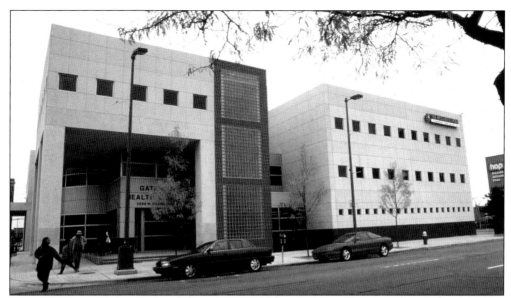

WELLNESS PLAN PLAZA HEALTH CENTER. Ground was broken on the Wellness Plan's Plaza Heath Center on August 24, 1994, on the corner of West Grand Boulevard and the Lodge Service Drive. The 62,000-square-foot building, built to deliver state-of-the-art medical services to Wellness Plan members, was designed by Albert Kahn Associates, Inc. and built by White Construction (both New Center businesses). (From the Collection of New Center Council, Inc.)

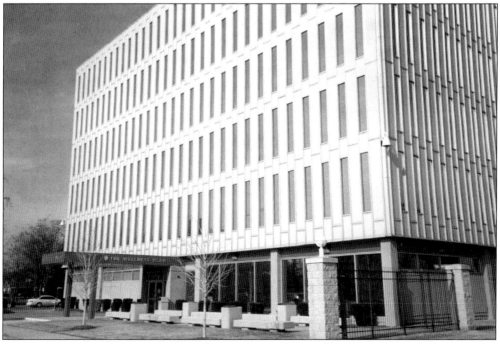

WELLNESS PLAN ADMINISTRATION BUILDING. The Wellness Plan is another one of Michigan's oldest and largest HMOs. The headquarters building of the Wellness Plan on Second Avenue (the former home of IBM in Detroit) was renovated in 2000 by Yamasaki Inc. (From the Collection of New Center Council, Inc.)

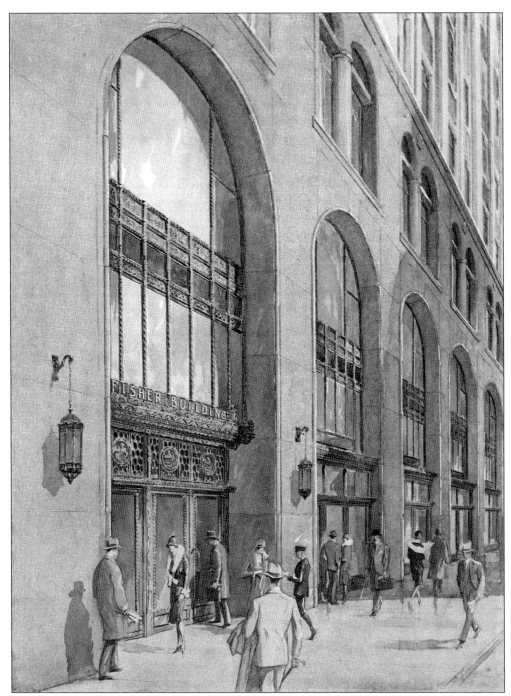

FISHER BUILDING PROFESSIONAL ENTRANCE. The leasing brochure for the Fisher Building explained that the "professional wing" of the Fisher Building was "designed for and reserved to the use of physicians, surgeons, dentists and others who devote their lives to the healing art." The professional wing is the 11-story wing that runs along Second Avenue. While not completely occupied by medical offices today, many doctors and dentists still call the professional wing of the Fisher Building home. (Courtesy of the Farbman Group.)

Two
GENERAL MOTORS BUILDING AND GM IN NEW CENTER

In the early 1920s, while downtown was crowded with buildings and people, New Center offered the land needed for the quickly-growing General Motors Company to build their corporate headquarters. In addition to the headquarters building, GM owned and operated many other properties in the neighborhood, helping to shape the area for more than 70 years. In 1996, GM announced that they would leave their long-time home and move downtown. Shortly after that, the State of Michigan announced that it would consolidate its Detroit offices in a newly-renovated General Motors Building—a national historic landmark. This project is considered the largest historic renovation in the country, after the Pentagon. The building was renamed Cadillac Place, and now houses over 2,700 state employees and ground floor retail.

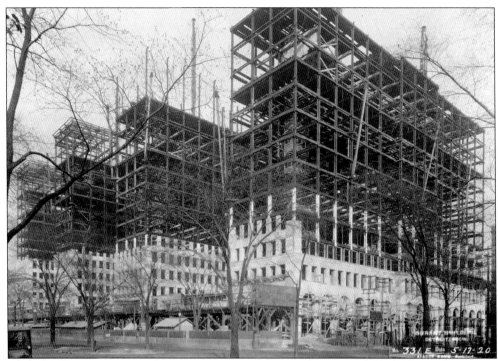

DURANT BUILDING. Ground was broken for the new headquarters building for General Motors on June 2, 1919. Originally to be named the Durant Building, after GM President W.C. Durant, this modern office structure would consist of 1.3 million square feet and would function as a city within a city. (Courtesy of General Motors Media Archive, Copyright 2004.)

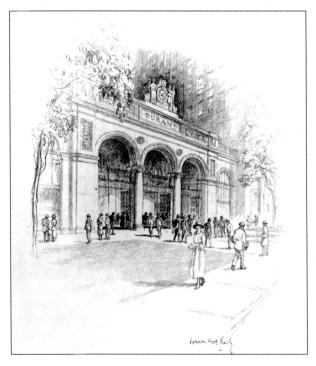

DURANT BUILDING. At the last minute, the name of the building was changed from the Durant Building to the General Motors Building. This change was made after W.C. Durant left the company for the second and final time. The letter "D" for Durant still adorns the building over the front door and along the roof line. (Courtesy of General Motors Media Archive, Copyright 2004.)

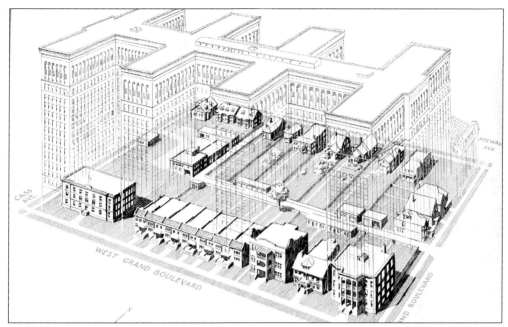

GENERAL MOTORS BUILDING. The General Motors Building, as it came to be called, occupies a complete city block. At the time of the groundbreaking in 1919, the area now known as New Center was nothing more than a quiet residential district three miles north of downtown. (Courtesy of General Motors Media Archive, Copyright 2004.)

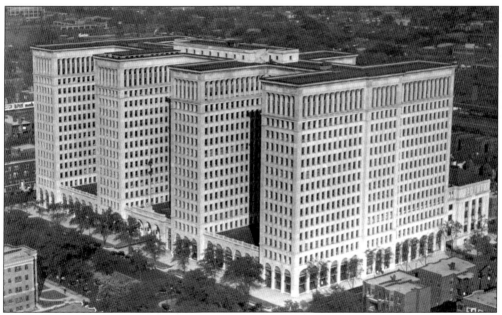

GENERAL MOTORS BUILDING. Designed by Albert Kahn and completed in 1922, the 15-story GM Building contained 24 elevators, multiple dining rooms and cafeterias, a billiards room, an auditorium, overnight rooms, car and product showrooms, retail, banking, a medical department complete with an infirmary for employees, a barber, and a beauty shop. (Courtesy of Albert Kahn Associates, Inc.)

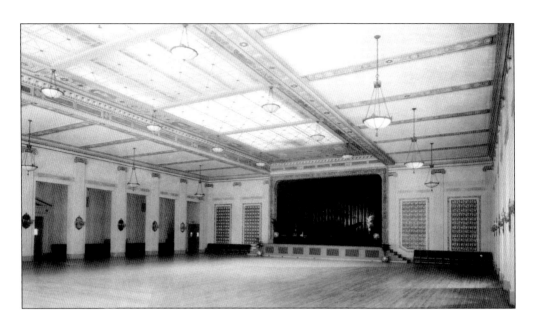

AUDITORIUM. The auditorium on the first floor of the General Motors building was truly a multi-purpose room. Because the chairs were not permanently fixed to the floor, the room could be used for traditional performances and concerts, conventions, dinners, dances, car unveilings, and more. When set up as a traditional auditorium with rows of chairs, the room could seat over 1,200 people. (Both photos courtesy of General Motors Media Archive, Copyright 2004.)

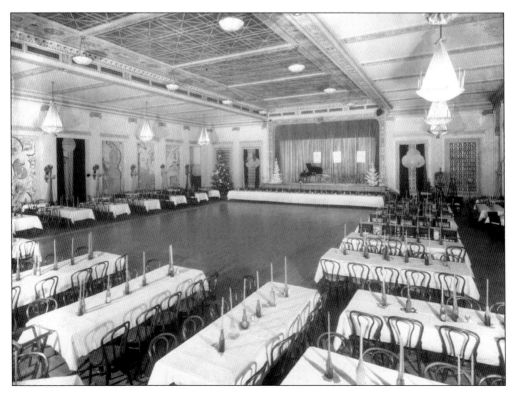

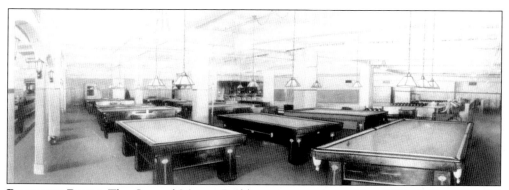

BILLIARDS ROOM. The General Motors Building was complete with a Billiards Room on the basement level. The room featured 20 billiards tables. (Courtesy of General Motors Media Archive, Copyright 2004.)

INFIRMARY. The infirmary in the GM Building was there to tend to the basic medical needs of GM's employees. (Courtesy of General Motors Media Archive, Copyright 2004.)

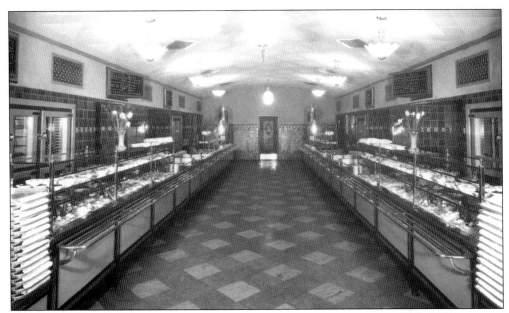

CAFETERIA. Dining options in the GM Building were numerous. The original cafeteria was located on the 15th floor and afforded excellent views of the growing city. The 14th floor featured executive dining rooms offering breakfast, lunch, and dinner. Another cafeteria was added in the basement and a "Heart Smart" restaurant was added on the first floor. (Courtesy of General Motors Media Archive, Copyright 2004.)

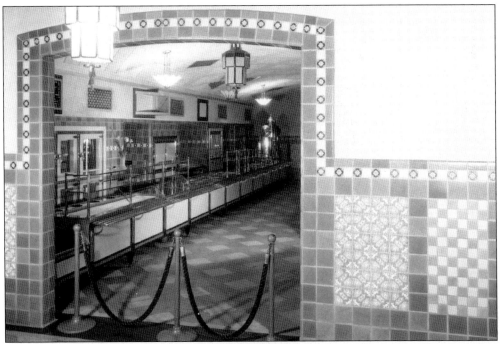

CAFETERIA. The basement of the GM Building originally housed a pool. The space was converted to a cafeteria very early on and the elaborate tile that surrounded the pool was retained as decoration. (Courtesy of General Motors Media Archive, Copyright 2004.)

GUEST SUITES. The General Motors Building originally featured 22 private rooms, complete with servants' quarters, for visiting executives. (Courtesy of Albert Kahn Associates, Inc.)

EXECUTIVE DINING ROOM. GM executives had private dining rooms on the 14th floor, and later, on the first floor of the building. (Courtesy of General Motors Media Archive, Copyright 2004.)

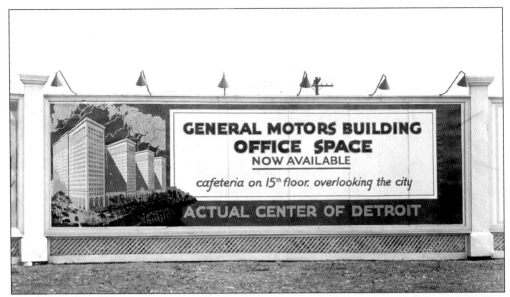

ADVERTISEMENT BILLBOARD. While later on, GM or companies doing business with GM, occupied all floors of the GM Building, in the early years of the building, space was offered for lease to the general public. This billboard proclaims the New Center as the "actual center of Detroit." (Courtesy of General Motors Media Archive, Copyright 2004.)

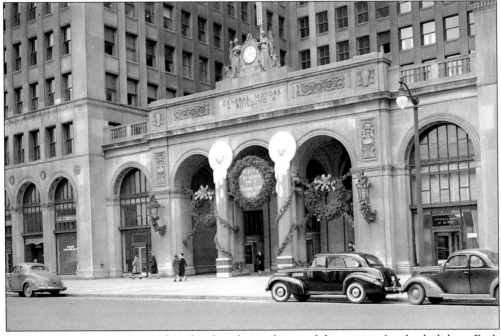

HOLIDAY TIME. New Center has developed a tradition of decorating for the holidays. Each year, great effort is taken to spread the holiday spirit through the installation of lights and garlands. (Courtesy of General Motors Media Archive, Copyright 2004.)

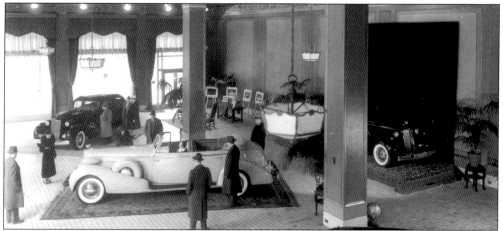

SHOWROOM, 1930s. (Courtesy of General Motors Media Archive, Copyright 2004.)

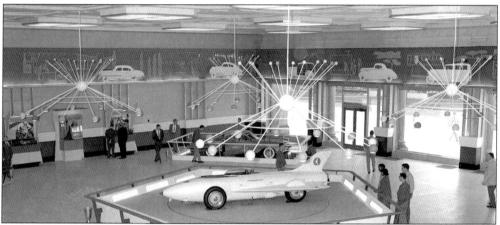

SHOWROOM, 1954. (Courtesy of General Motors Media Archive, Copyright 2004.)

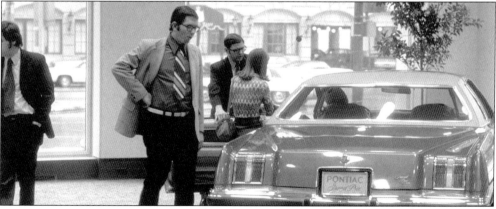

SHOWROOM, 1970s. The General Motors Building would not have been complete without multiple showrooms. These elaborate showrooms along the Boulevard, Cass Avenue, and Second Avenue sides of the building showcased the latest offerings from GM's stable of companies. (Courtesy of General Motors Media Archive, Copyright 2004.)

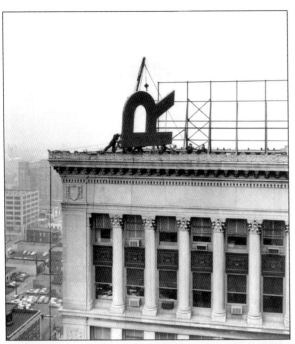

LETTERS ON TOP. In 1955, 15-foot neon letters spelling out "General Motors" were added to the west side of the building, and in 1960, matching letters were added to the east side of the building. (Courtesy of General Motors Media Archive, Copyright 2004.)

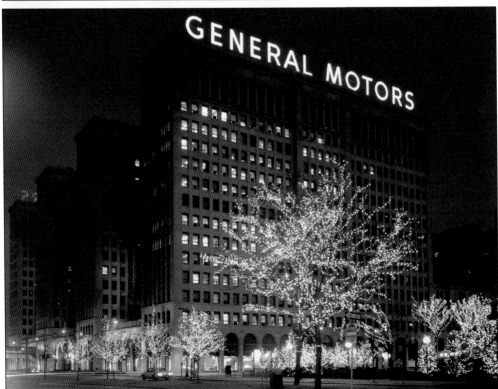

AT NIGHT. During the day when the neon lights were off, the letters were blue, but in the evening the familiar neon-red letters could be seen from miles away and quickly became a Detroit, and a New Center, landmark. (Courtesy of General Motors Media Archive, Copyright 2004.)

REMINGTON-RAND BUILDING. The Remington-Rand Building on West Grand Boulevard, just down the street from the former GM Building, was once home of the advertising firm Campbell-Ewald's annex. Their main offices were in the General Motors Building. Still in existence today, Campbell-Ewald has enjoyed a long relationship with General Motors, including accounts such as AC Delco, OnStar, and GMAC, and remains the only agency of record in the history of the Chevrolet Division. (Courtesy of General Motors Media Archive, Copyright 2004.)

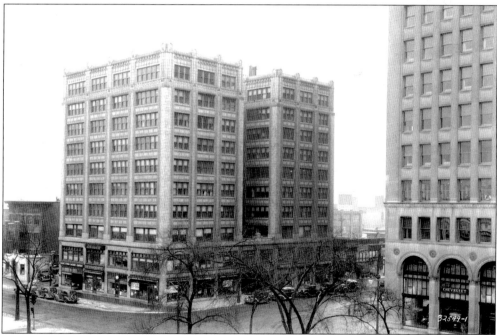

STEPHENSON BUILDING. Located across Cass Avenue from the General Motors Building, the Stephenson Building was home to various businesses related to General Motors, including some offices for Campbell-Ewald Advertising. The building was replaced by a "pocket park" in the late 1970s. (Courtesy of General Motors Media Archive, Copyright 2004.)

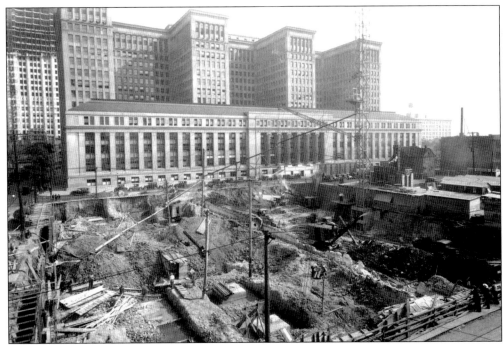

ARGONAUT BUILDING. More space was needed for the growing General Motors. The site chosen for the Argonaut Building was directly across Milwaukee Avenue just south of the General Motors Building. The building was built in two phases labeled "A" and "B." (Courtesy of General Motors Media Archive, Copyright 2004.)

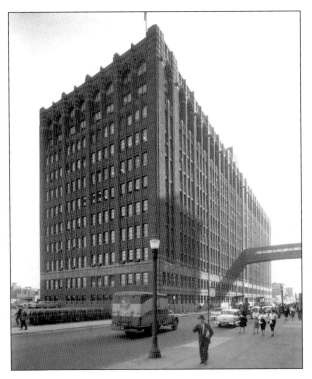

ARGONAUT BUILDING. The finished Argonaut Building, designed by Albert Kahn and completed in 1930, housed chemical and physical laboratories, shops, drafting rooms, and a library. A skywalk connects the Argonaut Building with the General Motors Building. (Courtesy of General Motors Media Archive, Copyright 2004.)

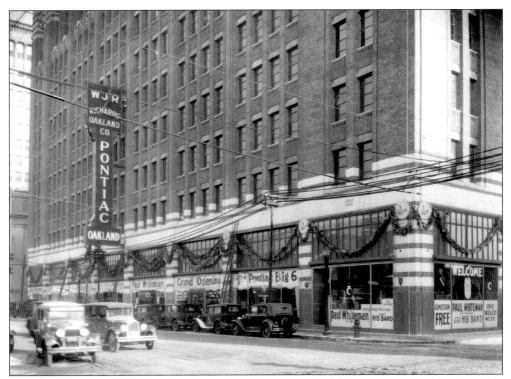

ARGONAUT BUILDING. The first floor of the Argonaut Building was occupied by the G.A. Richards Oakland Pontiac Showroom and Dealership. It was also home to WJR before it moved into the Fisher Building in 1928. (Courtesy of General Motors Media Archive, Copyright 2004.)

CAR ON THE ROOF. In order to evade the "auto paparazzi" of the day and to photograph the cars in natural daylight, new and prototype cars were taken to the roof of the Argonaut Building to be photographed. (Courtesy of General Motors Media Archive, Copyright 2004.)

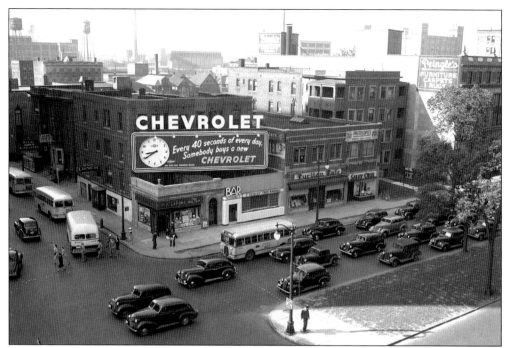

CHEVROLET CLOCK SIGN. A Chevrolet billboard, complete with a clock, was located on the corner of West Grand Boulevard and Second Avenue, right across from the General Motors Building. (Courtesy of General Motors Media Archive, Copyright 2004.)

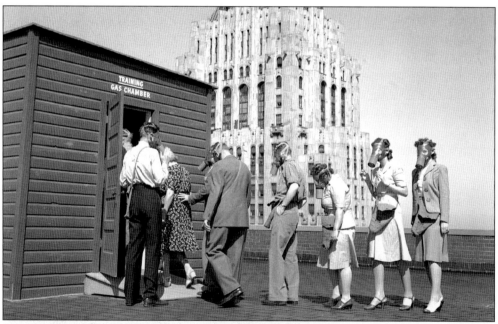

GAS CHAMBER. A "training gas chamber" was on the roof of the General Motors Building in the shadow of the nearby Fisher Building. Presumably, this was used to train employees in the event of an attack during World War II. (Courtesy of General Motors Media Archive, Copyright 2004.)

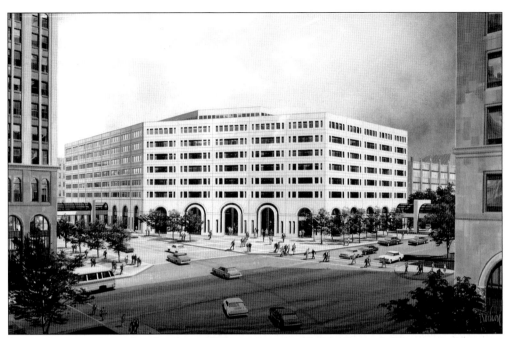

NEW CENTER ONE. In the late 1970s and early 1980s, General Motors made major contributions to maintain the neighborhood it called home. While the renovations that were taking place on the north end of New Center focused on homes, GM directed its attention to developing new commercial and retail offerings. The result of that attention was New Center One. (Courtesy of the Trizec Real Estate Services, LLC.)

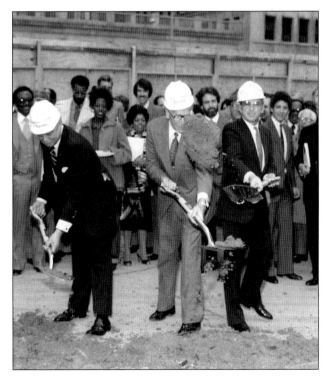

NEW CENTER ONE GROUND BREAKING. On April 29, 1980, ground was broken for the New Center One Building. A partnership between General Motors and real estate development company Trizec Corporation, this eight-story building would house many local and national retail stores, restaurants, offices, and various divisions of General Motors. (Courtesy of the Trizec Real Estate Services, LLC.)

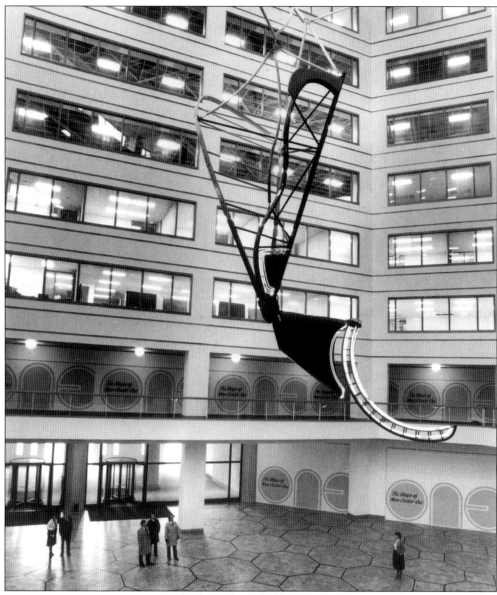

NEW CENTER ONE. New Center One was completed in January of 1983. Connected by skywalk to the historic Fisher and General Motors Buildings, New Center One became a hub of activity in New Center. A giant sculpture by S. Thomas Scarff, called "Jennifer's Butterfly," suspended in the huge atrium, added the final touch. (Courtesy of the Trizec Real Estate Services, LLC.)

"General Motors" Coming Down. Helicopters removed the General Motors neon letters from the top of the building in April of 2000, after General Motors moved to the Renaissance Center downtown. The lights came on for the last time in December of 1999, a couple months before they were removed. It was an end of an era and the beginning of a new one for New Center. (Photograph by Larry Kinsel.)

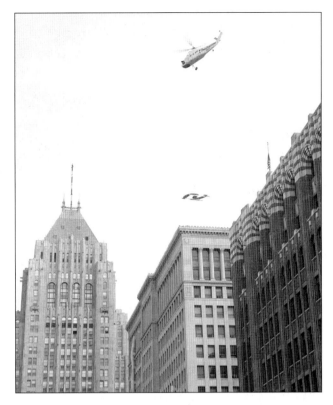

Cadillac Place. In 1996, General Motors announced their move to the Renaissance Center.

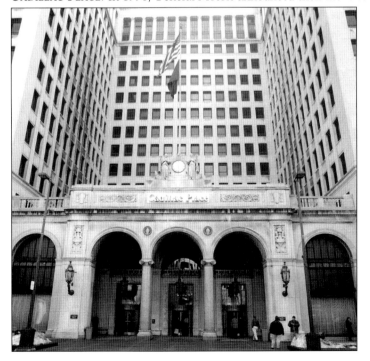

Albert Kahn Associates, Inc., the firm whose founder originally designed the building, led the design team for the adaptive reuse and was the architect on record for the project. The former GM Building was completely renovated and master-leased by the State of Michigan. In a 2002 ceremony, then-Governor John Engler officially renamed the building Cadillac Place. The building is currently home to approximately 2,700 state employees and many retail businesses on the ground floor and concourse level. (Photograph by Elizabeth Solaka.)

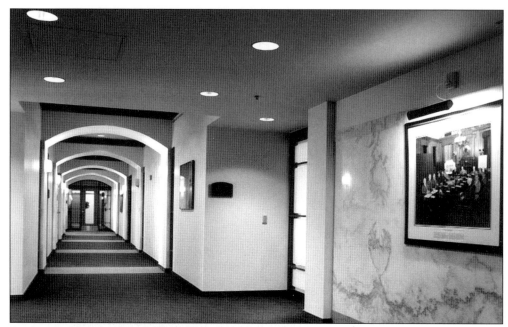

CADILLAC PLACE. The State of Michigan consolidated many of its offices and departments from throughout southeastern Michigan, including the Michigan Court of Appeals, into the renovated Cadillac Place. With the assistance of the GM Media Archive, Judge Michael Talbot decorated the hallways of the court on the 14th floor with historical photos of the GM Building. (Photograph by Elizabeth Solaka.)

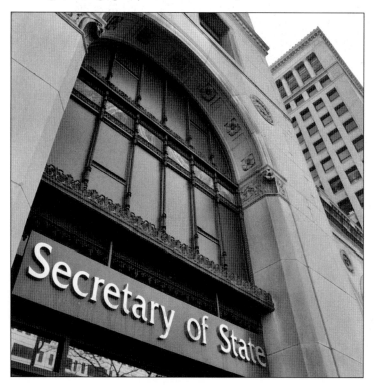

CADILLAC PLACE. When the State took over Cadillac Place, the local branch of the Secretary of State moved into ground floor space that formerly occupied GM's east showroom. (Photograph by Elizabeth Solaka.)

Three
FISHER BUILDING AND THE FISHER BROTHERS

The Fisher brothers developed the closed carriage, which revolutionized the growing auto industry and allowed for automobile travel all year long. Their major customer, General Motors, eventually acquired sole ownership of the Fisher Body Corporation and the "Body by Fisher" name, but not before the Fisher brothers had left a permanent mark on New Center. The Fisher brothers were the first to conceptualize of a "new center." Following General Motors, the brothers built their Fisher and New Center Buildings in what was, at that time, the true geographical center of the city.

THE FISHER BROTHERS. The seven sons of Lawrence Fisher Sr., a carriage builder in Ohio, the Fisher brothers made their fortunes by founding the Fisher Body Company in Detroit. The brothers Fredrick, Charles, William, Lawrence, Edward, Alfred, and Howard built carriages (bodies) for the emerging auto industry. They later sold their company to General Motors. (Courtesy of the Farbman Group.)

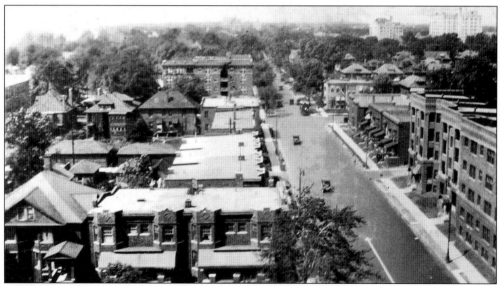

FISHER BUILDING. The Fisher brothers chose a primarily residential site—bound by West Grand Boulevard, Second Avenue, Lothrop, and Third Avenue—for the Fisher Building. While much of the architecture that existed at the time of construction in 1927 is now gone, the apartment building at the corner of Second Avenue and Lothrop (visible in the center background of this photo) still remains today. (Courtesy of the Burton Historical Collection, Detroit Public Library.)

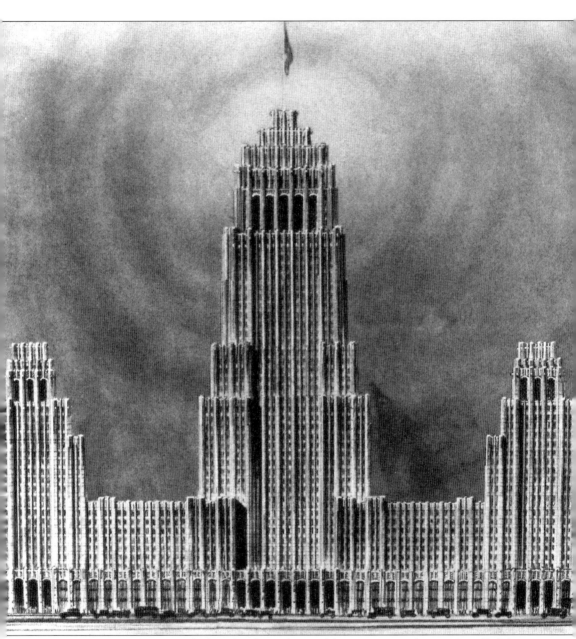

FISHER BUILDING. The original plans for the Fisher Building, announced in 1927, called for three towers, but because of the Great Depression, those idealistic plans were never brought to fruition, and only one tower (the one to the right) was built. (Courtesy of Albert Kahn Associates, Inc.)

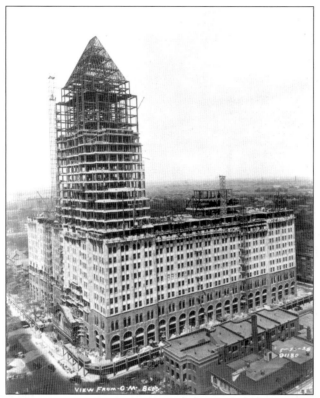

FISHER BUILDING. Ground was broken on the seven-acre site in August of 1927. No expense was spared in the construction of the Fisher Building. Architect Albert Kahn was given a "blank check" for the creation of what was to become "Detroit's largest art object." (Courtesy of Albert Kahn Associates, Inc.)

FISHER BUILDING FROM THE LEXINGTON HOTEL. Located across West Grand Boulevard from the recently completed GM Building, the Fisher Building became an instant Detroit landmark and helped transform the area from a rural residential neighborhood, three miles north of downtown, into Detroit's New Center, a mixed-use destination filled with shops, offices, and housing. (Courtesy of the Burton Historical Collection, Detroit Public Library.)

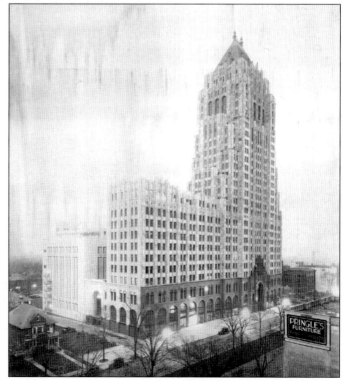

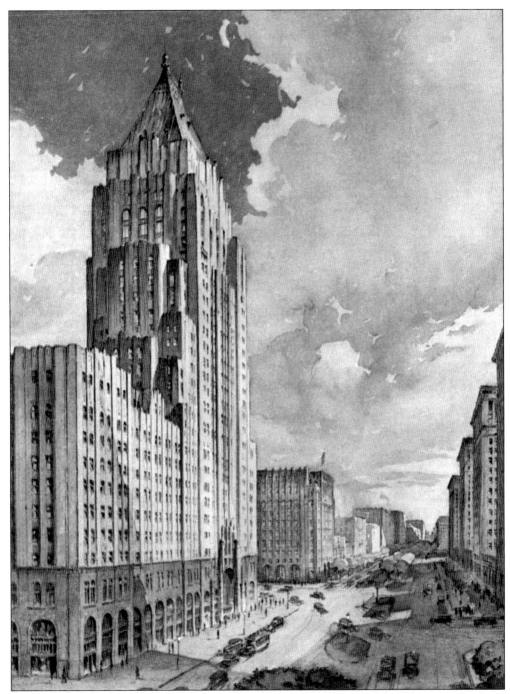

FISHER BUILDING. The Fisher Building was awarded the Silver Medal as the most beautiful commercial building of 1928 by the Architectural League of New York. The building was declared a National Historic Landmark in 1989 by the U.S. Department of the Interior. (From the Collection of New Center Council, Inc.)

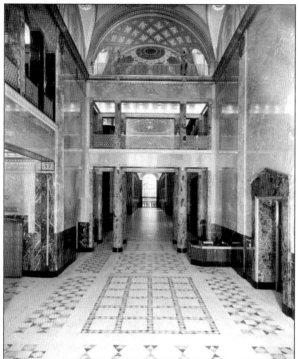

LOBBY. The lobby of the Fisher Building features 40 types of marble from around the world and elaborate bronze detailing, including one-of-a-kind elevator doors on two banks of elevators. Exquisite paintings by Hungarian artist Géza Maróti cover the ceilings. The designs feature symbols of commerce and industry with no shortage of gold leaf. (Courtesy of Albert Kahn Associates, Inc.)

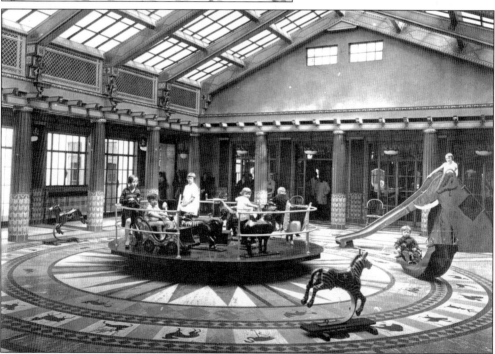

CHILDREN'S PLAY ROOM. Opened in 1928, the Fisher Building included many modern amenities to appeal to the shoppers, including a children's play room. The day care, on the fourth floor, featured a skylight, mosaic floors, and a carousel. Children played under the supervision of professional nurses. (Courtesy of the Farbman Group.)

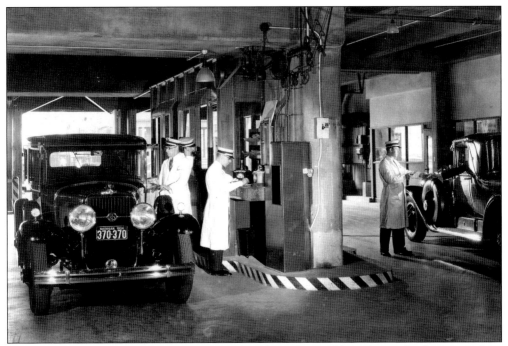

GARAGE. The 11-story garage, contained within the Fisher Building, featured valet service from uniformed attendants. Two-hour free parking was offered to lure shoppers to the New Center. (Courtesy of the Trizec Real Estate Services, LLC.)

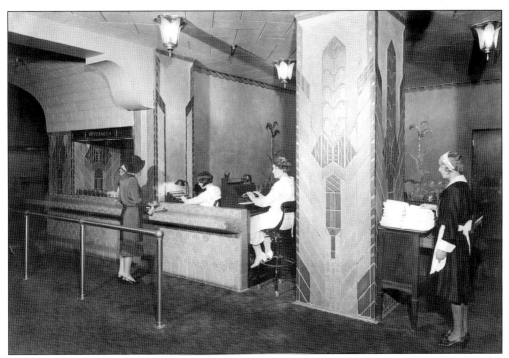

CAFETERIA. The Fisher Cafeteria was located in the basement of the Fisher Building in the space that is currently occupied by the Club House Tavern. (Courtesy of the Farbman Group.)

RECESS CLUB. The Recess Club, one of the first tenants of the Fisher Building, was a private business and professional club on the 11th floor. The Club opened on November 7, 1928, and featured fine dining and opportunities to network with colleagues, clients, and politicians. Because of declining membership, the Recess Club closed in 1990. (From the Collection of New Center Council, Inc.)

TUNNELS TO THE GENERAL MOTORS AND NEW CENTER BUILDINGS. Underground walkways connect the Fisher Building to Cadillac Place (former GM Building) and the Albert Kahn Building (former New Center Building). It is rumored that the walkways were constructed by one of the Fisher brothers so that his wife could travel from the Fisher Building to the neighboring buildings without having her hair mussed by the strong winds that whip along the Boulevard. There is also speculation that the tunnels were designed to be connected to a Detroit subway system, but no such system was built. (Courtesy of the Burton Historical Collection, Detroit Public Library.)

FISHER BUILDING. Standing 28 stories tall, the "golden tower" of the Fisher Building has been a Detroit landmark since its creation. Originally the roof was gilded in gold, but the gold was removed during World War II for fear that the building would attract enemy bombers. The "golden" effect is now created by lights with colored lenses. (Courtesy of the Trizec Real Estate Services, LLC.)

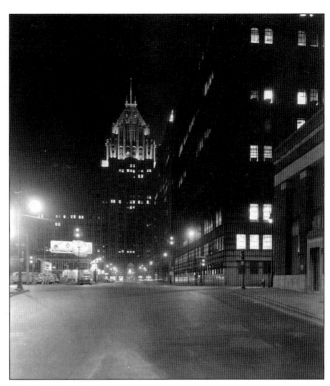

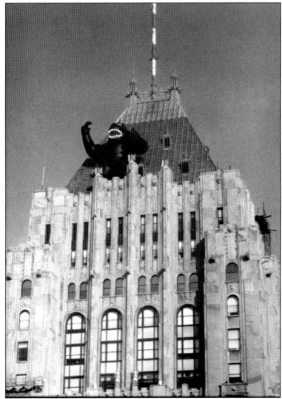

FISHER BUILDING. While the top of the Fisher Building is usually "golden," the color and sometimes the appearance are changed when occasion necessitates. During the National Hockey League's Stanley Cup Playoffs of the mid-1990s, featuring the Detroit Red Wings, a giant, inflatable octopus was added to the top of the building and the lights were changed to reflect the team's color, red. During a special fundraising stair-climb event in 1991, a giant gorilla was added. Each year, the top is lit green in honor of St. Patrick's Day. (Courtesy of Trizec Real Estate Services, LLC.)

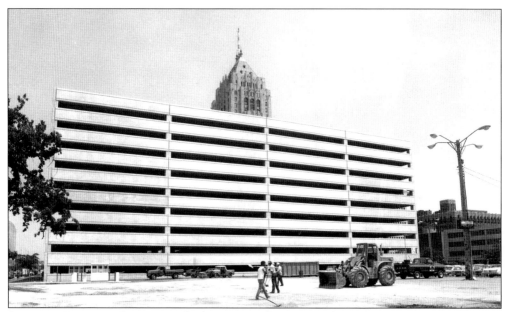

PARKING DECK. To keep up with the constantly growing demand for parking and for the increased demand brought on by the construction of New Center One, Trizec Corporation, owners of the Fisher Building from 1974 to 2001, partnered with General Motors to build a 10-story, 1,700-car parking deck in 1981. (Courtesy of the Trizec Real Estate Services, LLC.)

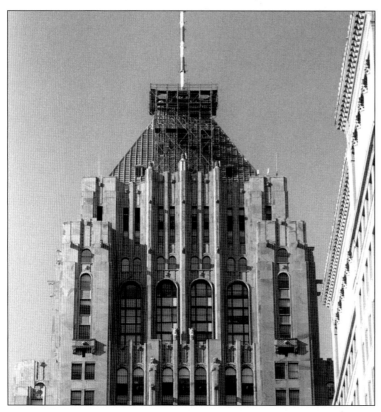

FISHER BUILDING TOP REPAIR 2003. In order to maintain the historic profile of the landmark Fisher Building, Farbman Group, owners of the Fisher Building since 2001, went to considerable effort and expense to replace the spires on the top of the building. Originally built out of wood, the decorative structures had decayed beyond repair and were replaced in 2003. (Photograph by Esteban.)

Four
ALBERT KAHN AND
ALBERT KAHN ASSOCIATES

Architect Albert Kahn made his mark on the world, but nowhere is it more evident than in Detroit's New Center. New Center is home to a wonderful collection of Kahn buildings, including the landmark Fisher Building, Cadillac Place (formerly General Motors Building), and the Albert Kahn Building (formerly New Center Building), which still houses the architecture firm that Kahn founded. Besides these office buildings, New Center is also home to many examples of the industrial buildings that Kahn is best known for.

ALBERT KAHN. The son of a rabbi, Albert Kahn was born in Germany in 1869 and immigrated to Detroit in 1880. Needing to work to help support a large family meant the end of his formal education at age 11. He was fortunate to find two mentors—Julius Melchers, a sculptor and artist, who taught him drawing skills, and George Mason, an architect in Detroit, who taught him design. In 1891 Albert won a scholarship for a year of study abroad and traveled through Italy, France, Belgium, and Germany sketching the great architecture of Europe. Upon his return, he applied his new knowledge and soon became head of design at Mason & Rice. In 1896, Kahn left Mason & Rice to start his own firm and married Ernestine Krolick, the daughter of a local dry goods distributor. In 1903 his brother Julius joined his firm as chief engineer. Julius is responsible for perfecting the reinforced concrete steel truss, instrumental in the creation of the industrial architecture that Albert is so widely known for, and went on to establish the Trussed Concrete Steel Company in Youngstown, Ohio. A successful collaboration with Henry Ford produced the Ford Highland Park Plant, where Ford perfected the moving assembly line. This was the beginning of a long relationship between Kahn and Ford that resulted in over 1,000 projects. Believing that form follows function, Kahn configured the structure for maximum economy and utility—exactly what the manufacturing industry wanted. His buildings introduced extensive sky lighting and ventilation concepts, which greatly improved the worker environment, and massive expanses of open space, which facilitated new efficient manufacturing practices. Kahn died in 1942. While he is best known for his contribution to industrial architecture, he made significant and lasting contributions to civic, institutional, commerical, and domestic architecture and can easily be considered Detroit's most famous architect. As a testament to his lasting legacy, the firm that bears his name, Albert Kahn Associates, Inc., is still thriving in New Center today. (Courtesy of General Motors Media Archive, Copyright 2004.)

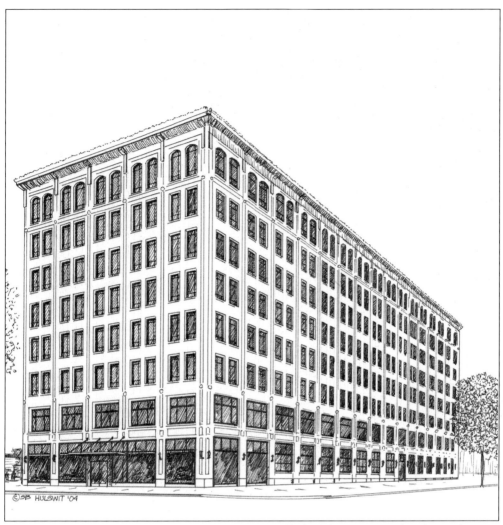

©SB HULSWIT '04

FORD MOTOR COMPANY SERVICE BUILDING. Originally built by Henry Ford as the Ford Motor Car Service Building, the eight-story Albert Kahn-designed Boulevard Building, as it came to be known, was purchased by two real estate developers in 1919 from Ford. The developers transformed the building from industrial to office space, and in 1925 renovation plans were announced for the creation of a modern office building with retail, offices, an attractive lobby, and nine elevators. This building was part of the beginning of what would become Albert Kahn's major architectural contribution to the area. (Drawing by Shannon Bergt Hulswit.)

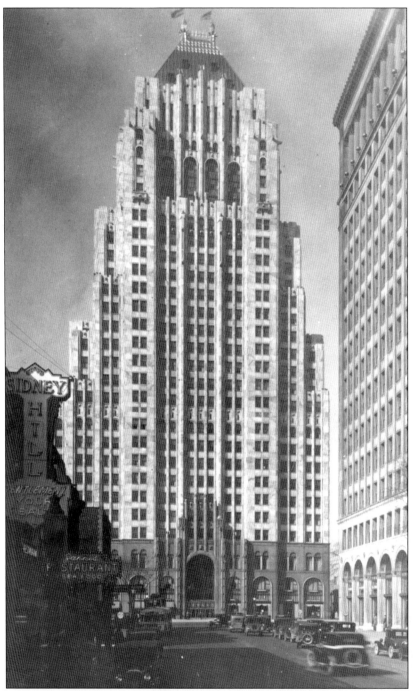

Fisher Building. The Fisher Building is considered by many to be Albert Kahn's best work. Built in 1928, the Fisher Building was possibly influenced by the New York Life Insurance Company Building in New York. While the roof shape of the Fisher Building is influenced by Gothic architecture like the New York Life Building, the prominent arches on the first three levels, continued from the General Motors Building, are Romanesque. (Courtesy of Albert Kahn Associates, Inc.)

GENERAL MOTORS BUILDING. The size of the General Motors Building presented a great design challenge for Albert Kahn. His mastery of scale and commitment to workers' comfort are evident in the straightforward yet functional design that contained open courts to allow for light and air for the many offices. Minimal ornamentation, simple but elegant interiors, and a striking triple-arched entrance portico were prevalent design features. (Courtesy of Albert Kahn Associates, Inc.)

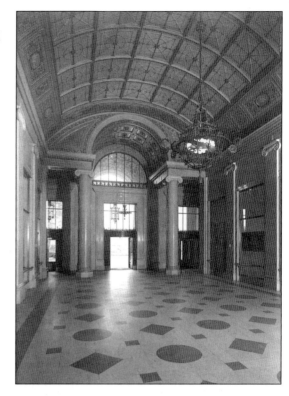

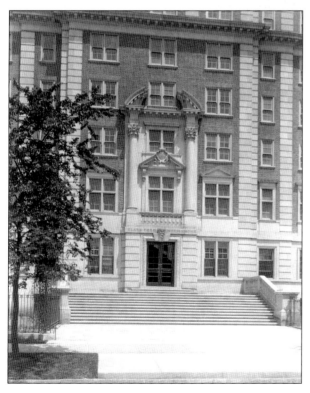

HENRY FORD HOSPITAL. Although Albert Kahn was not the first architect to design a building for Henry Ford Hospital, he definitely left his mark with the Clara Ford Nurses Building, the Education Building, and others. Typical of Albert Kahn, he designed buildings that were both highly functional and immensely beautiful. Influenced by his overseas travel, Kahn incorporated designs of the past into truly "modern" and aesthetically pleasing designs of the day. (Courtesy of Albert Kahn Associates, Inc.)

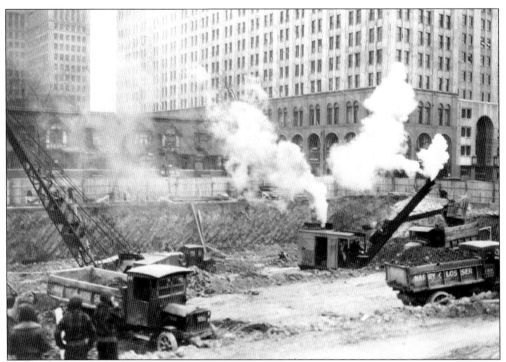

NEW CENTER BUILDING. The Fisher brothers' second contribution to the growing New Center was the New Center Building. The building was located on the corner of Second Avenue and Lothrop, diagonal from the Fisher Building. The building was completed in 1931. (Courtesy of General Motors Media Archive, Copyright 2004.)

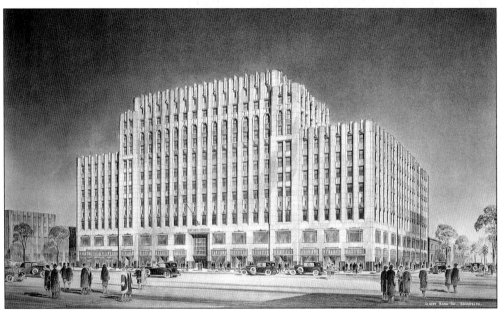

NEW CENTER BUILDING. The 10-story building, in a style similar to the Fisher Building, originally featured both office and retail space, but now strictly houses offices. It is connected to the nearby Fisher Building via an underground tunnel. (Courtesy of the Trizec Real Estate Services, LLC.)

ORIGINAL ENTRANCE. Designed by architect Albert Kahn and originally named the New Center Building, the building has housed the architectural firm that bears his name since it opened in 1932. (Courtesy of Albert Kahn Associates, Inc.)

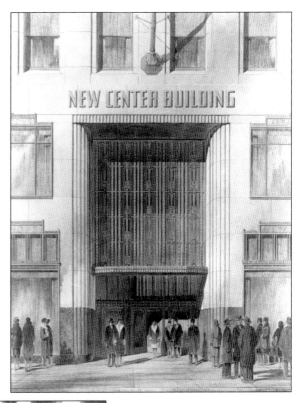

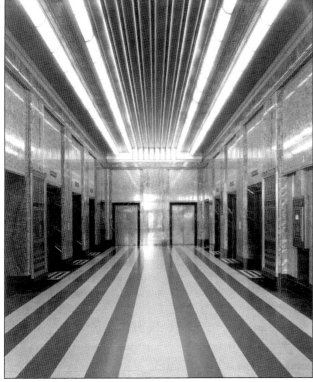

LOBBY. The lobby of the New Center Building is a wonderful example of streamlined Art Deco design. Again, Albert Kahn used only the best materials including polished marble floors and bronze elevator doors. (Courtesy of Albert Kahn Associates, Inc.)

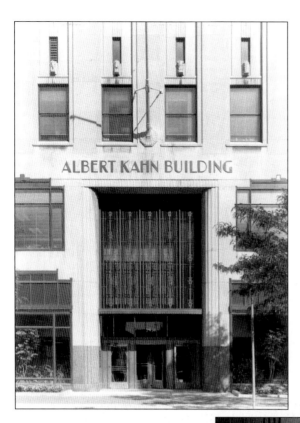

ENTRANCE, 1988. In October of 1988, the building was renamed the Albert Kahn Building to honor its architect. (Courtesy of Albert Kahn Associates, Inc.)

CURRENT OFFICE SPACE. Today, the firm founded by Albert Kahn over 100 years ago continues to prosper and is active worldwide. Albert Kahn Associates, Inc. (AKA) is a leading planning, design, and management firm, serving the industrial, health care, higher education, commercial, interiors, R&D technology, urban design, and government markets. (Courtesy of Albert Kahn Associates, Inc.)

Five
New Amsterdam Historic District and the Early Auto Industry

The New Amsterdam historic district, as it is now called, is the southern-most area of New Center. This part of the city bore witness to much of the auto industry's early years. Early on, it was home to many of the small automakers and suppliers that grew and merged into the auto industry of today. Currently, the area is receiving a new life as the home of Wayne State University's Research and Technology Park (known as "TechTown"). Additionally developers are working to make the area a true 24-hour district through the conversion of several industrial buildings into residential lofts and retail.

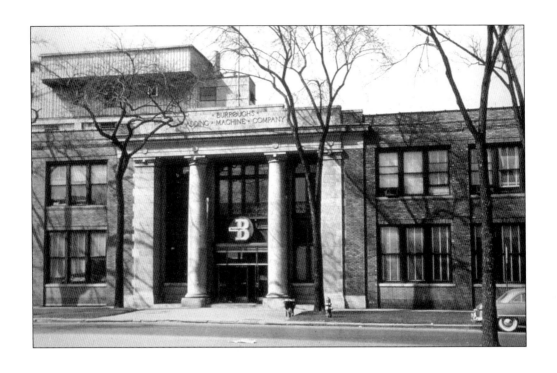

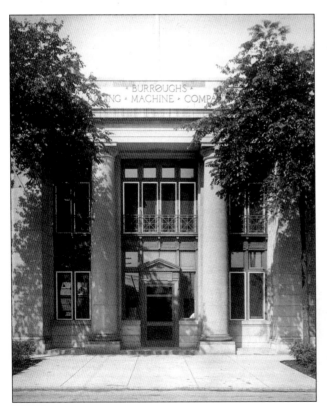

BURROUGHS ADDING MACHINE COMPANY. Co-founded in 1886 in St. Louis by William Seward Burroughs as the American Arithmometer Co., Burroughs Corporation was one of the first businesses located in what would become New Center. In 1904 the entire company—equipment, offices, employees and their families—moved to Detroit from St. Louis on two chartered trains. (Top photo from the Collection of New Center Council, Inc. Bottom photo courtesy of Albert Kahn Associates, Inc.)

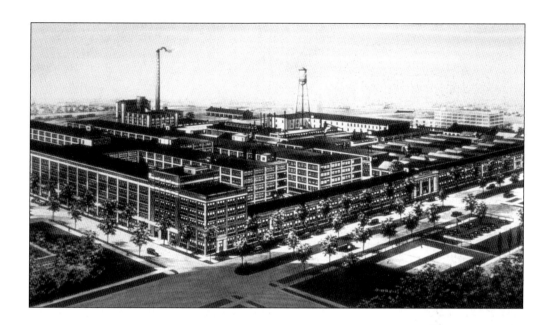

BURROUGHS ADDING MACHINE COMPANY. In 1905 the company's name was changed to the Burroughs Adding Machine Company. Always a leader in technology, after World War II, Burroughs moved from adding machines to the growing field of computers. The manufacturing plant and offices of Burroughs covered an entire city block. (Top photo from the Collection of New Center Council, Inc. Bottom photo courtesy of Albert Kahn Associates, Inc.)

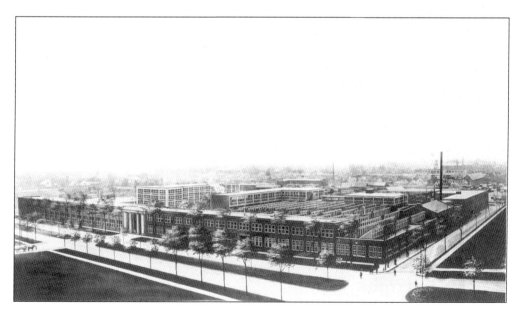

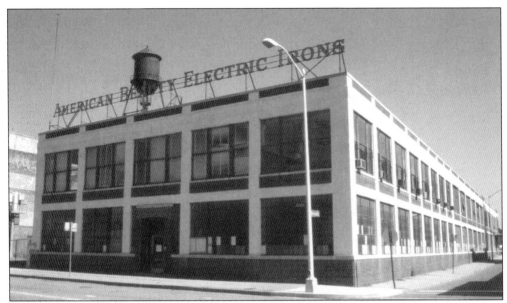

AMERICAN ELECTRICAL HEATER CO. The American Electrical Heater Company, founded in 1894 by brothers Frank and Robert Kuhn, produced heating devices under the brand name "American Beauty." Their manufacturing plant on Woodward Avenue underwent multiple changes, including the removal of part of the building to accommodate the widening of Woodward Avenue, and a later addition in 1934 that extended the building to Cass Avenue. (From the Collection of New Center Council, Inc.)

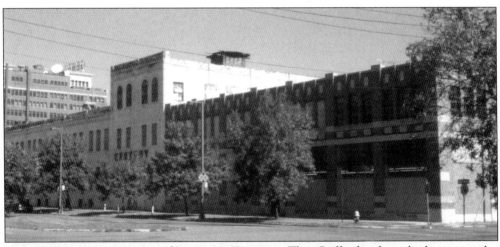

CAILLE BROTHERS COMPANY/CENTURY FLORIST. The Caille brothers built penny slot machines and outboard motors in the Caille Building on Second Avenue. The building was constructed in various stages between 1900 and 1930. A. Arthur Caille, the inventor of the penny slot machine, was also the owner and builder of many of Detroit's finest movie palaces. Later, the building was occupied by the Century Florist Supply. (From the Collection of New Center Council, Inc.)

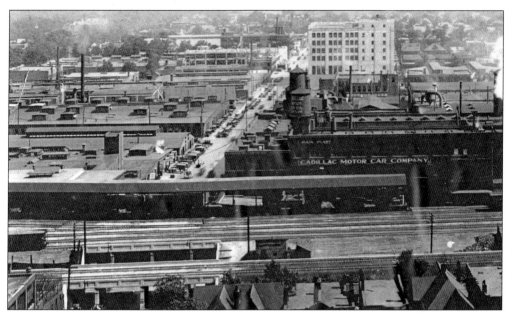

CADILLAC MOTOR CAR CO. ASSEMBLY PLANT. Designed by architect George D. Mason in 1905 and utilizing reinforced concrete construction pioneered by Albert Kahn's brother, Julius, the Cadillac Motor Car Company Amsterdam Street Plant was built in only 67 days. In 1920, Cadillac production was moved to the Clark Street Plant in southwest Detroit. (Courtesy of Westcott Displays.)

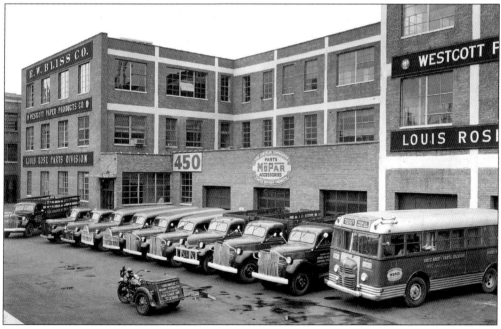

WESTCOTT DISPLAYS. After Cadillac moved production, the Amsterdam Street Plant was purchased by the Westcott Paper Co. and occupied by Westcott and other tenants. Westcott Paper Co., a printer specializing in point-of-purchase displays, still occupies the building today. (Courtesy of Westcott Displays.)

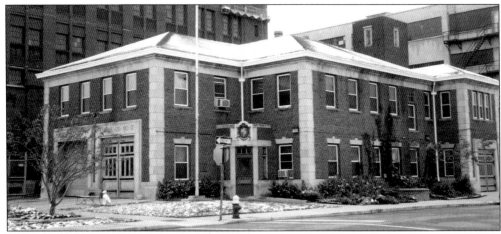

LADDER COMPANY NO. 7/ENGINE COMPANY NO. 17. Ladder Company No. 7 and Engine Company No. 17's new building on Burroughs and Second Avenue was opened in 1923. The building has been in continual use as a fire station since its dedication. (From the Collection of New Center Council, Inc.)

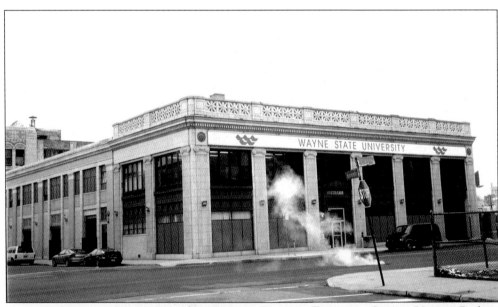

STEWART-WARNER SPEEDOMETER/BURROUGHS DETROIT EMPLOYEE CREDIT UNION. Built in 1925, this building was originally home to the Stewart-Warner Speedometer Company. In the 1960s, the building was converted from a wheel and brake shop to the Burroughs Detroit Employee Credit Union. Later, the building was purchased by Wayne State University and currently houses their parking, mail, and other departments. (From the Collection of New Center Council, Inc.)

GRAPHIC ARTS BUILDING. The Graphic Arts Building at 41-47 Burroughs was designed by architects Murphy & Burns. Built in 1926, this 50,000-square-foot four-story terra cotta building was built to house businesses that were involved in some aspect of graphic arts. Original tenants included a commercial photo engraver, a commercial photographer, and an art studio. (From the Collection of New Center Council, Inc.)

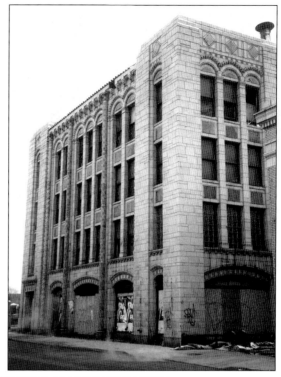

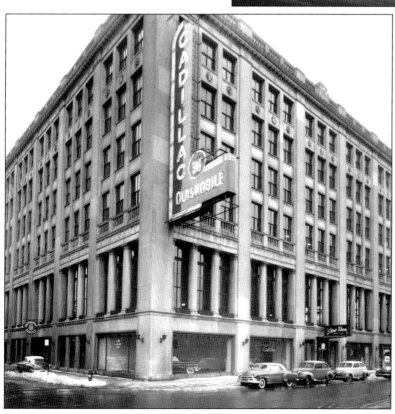

CADILLAC SALES & SERVICE. Originally built as the Cadillac Sales and Service Building in 1927, this building at 6001 Cass Avenue housed offices and a Cadillac showroom. The six-story structure was converted into classrooms in the 1970s and is currently owned by Wayne State University. (Courtesy of General Motors Media Archive, Copyright 2004.)

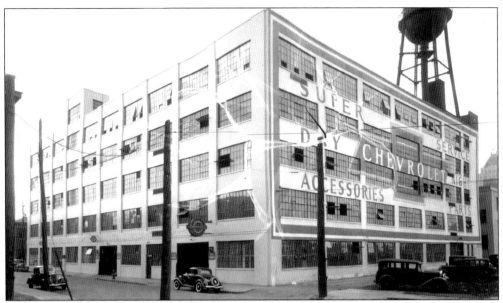

CHEVROLET SERVICE BUILDING. This structure at 440 Burroughs was built in 1927 for George A. Richards as the G.A. Richards Oakland Company Service Department for Pontiacs and Oakland automobiles. The showroom for the dealership was in the nearby Argonaut Building. Richards, a prominent Detroiter, also owned WJR Radio and the Detroit Lions. The building later housed a Super Chevy repair shop and then became known as the Chevy Creative Service Building. Displays for auto shows around the country were designed and built here. (Courtesy of General Motors Media Archive, Copyright 2004.)

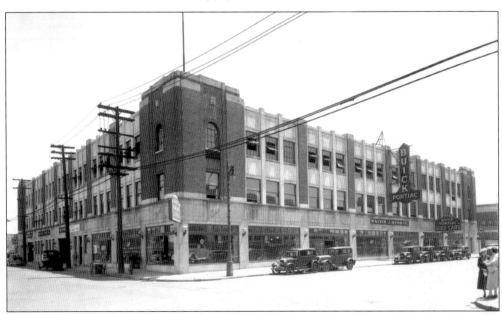

WALTER J. BEMB BUICK-PONTIAC DEALERSHIP. Designed by Albert Kahn in 1927, this building at 6160 Cass Avenue originally housed the Detroit branch of the Buick Motor Division and the Walter J. Bemb Buick-Pontiac Dealership. See Dalgleish Cadillac. (Courtesy of General Motors Media Archive, Copyright 2004.)

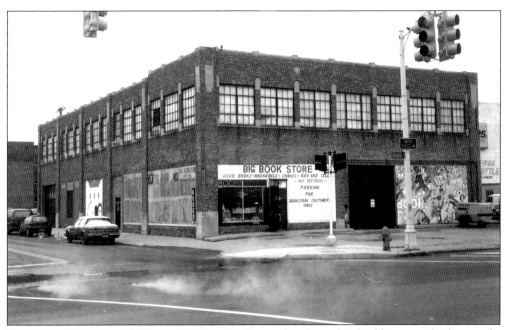

FIRESTONE BUILDING. Built in 1930 by the Carney brothers, this building was the home of a Firestone garage until 1990, when it was converted to a used book store. (From the Collection of New Center Council, Inc.)

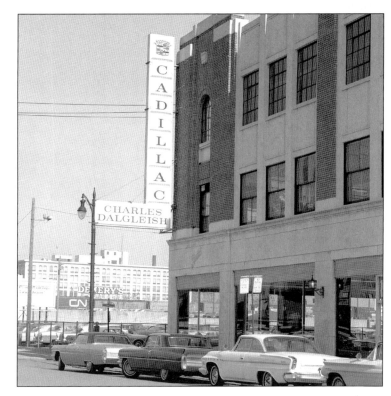

DALGLEISH CADILLAC. In 1972, the former Buick Motor Division Building was purchased by Dalgleish Cadillac and currently houses a showroom on the first floor and repair facilities on the second and third floors. Cars are moved between floors via a concrete ramp. (Courtesy of General Motors Media Archive, Copyright 2004.)

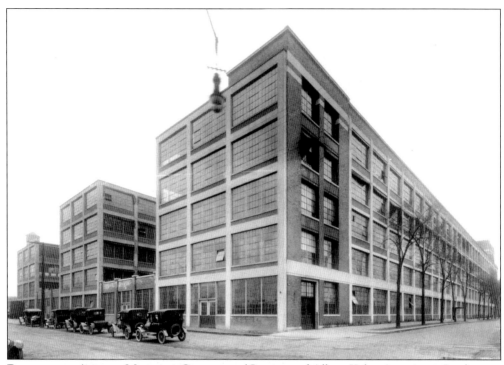

BURROUGHS ADDING MACHINE COMPANY. (Courtesy of Albert Kahn Associates, Inc.)

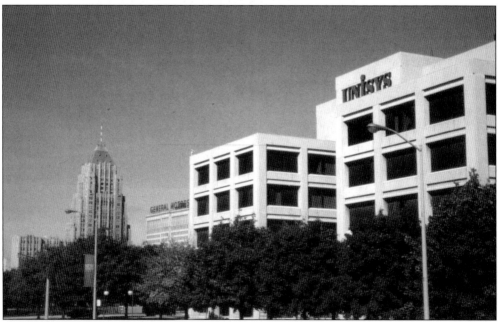

UNISYS. In 1986 Burroughs (formerly Burroughs Adding machine) merged with Sperry, and the new company was known as Unisys. In 1971 a new headquarters was built on skeletal elements of the original manufacturing plant (see above). The new building, designed by architects Smith & Gardner, was 532,000 square feet on five stories and featured a sunken lobby. (Courtesy of Albert Kahn Associates, Inc.)

Six
RETAIL, RESTAURANTS, AND HOTELS

New Center was, and remains today, a great place for shopping and dining. While the business names and owners have changed over the decades, the variety is still here. In the early days, visitors were treated to fine dining and luxury department store shopping. Now, visitors come for galleries, services, boutique shopping, and both fine and informal dining.

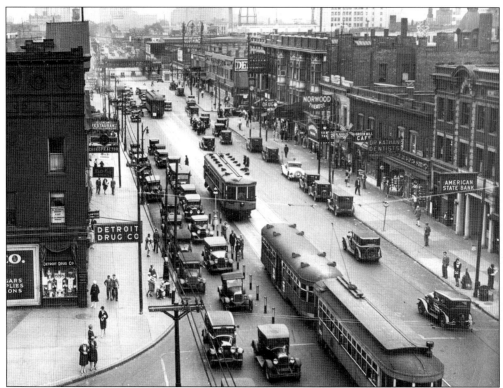

WOODWARD AVENUE. Shopping has always been an important attraction to New Center. While newer buildings like the General Motors and Fisher Buildings on the Boulevard provided stores in an enclosed setting, Woodward Avenue already had a strong mix of retail stores. Storefronts stretched from West Grand Boulevard south to the railroad overpass. (Courtesy of the Burton Historical Collection, Detroit Public Library.)

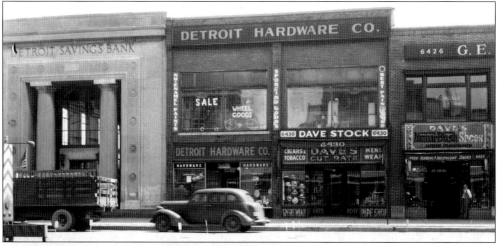

DETROIT HARDWARE. Detroit Hardware was founded in 1924 by Margaret Clark Paschall. In 1926, Albert Green began working there and Jack Hocking joined him in 1930. In 1959 the two men bought the store from Paschall, and today Green's daughter and Hocking's son own the store. Granddaughters from both families work there, too. (Courtesy of Emily Webster.)

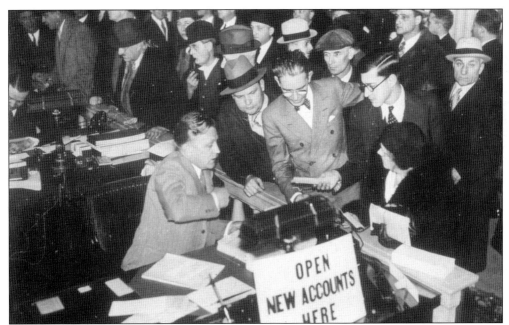

BANKING IN NEW CENTER. New Center has always been home to various branches of local and national banks, including Comerica in the Fisher Building, Standard Federal in New Center One, and Bank One in Cadillac Place. Recently, more credit unions have located in New Center to be accessible to the State of Michigan employees in Cadillac Place and Detroit Public Schools employees in the Fisher and New Center One Buildings. (From the Collection of New Center Council, Inc.)

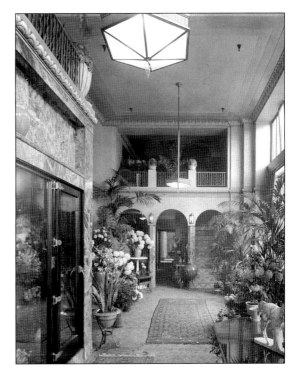

FISHER BUILDING FLOWER SHOP. From 1928 to 2001, a flower shop (under various names and owners) occupied the Fisher Building storefront at the corner of Second Avenue and Lothrop. (Courtesy of the Farbman Group.)

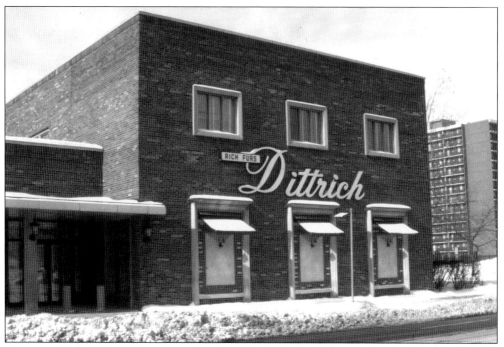

DITTRICH FURS. Dittrich Furs moved to their Third Avenue location shortly after the company was founded by Emil C. Dittrich in 1893, and still does business there. Possibly the oldest retail operation in New Center and one of the oldest in the city, Dittrich Furs expanded their building in 1987 to 35,000 square feet. (From the Collection of New Center Council, Inc.)

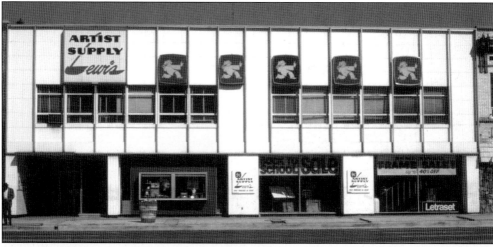

LEWIS ART SUPPLY. In 1927, Jack Lewis, a former chart maker for Chevrolet, moved his Lewis Artist Supply from downtown to New Center. (From the Collection of New Center Council, Inc.)

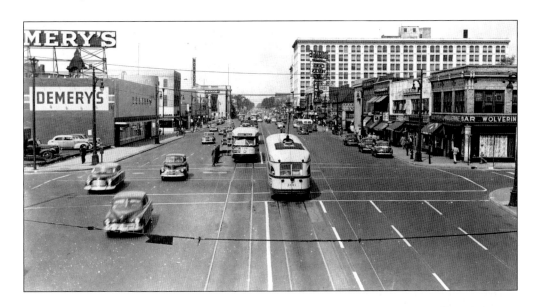

WOODWARD AVENUE. Beginning in the 1920s, New Center developed two strong retail cores; Woodward Avenue and West Grand Boulevard. Before the days of suburban shopping malls, Woodward Avenue, in both downtown and New Center, attracted throngs of people for shopping, lunch, or perhaps a movie. The Norwood Theater, located on the west side of Woodward Avenue, was designed by architect William S. Joy in 1915. It remained a theater until 1949. (Top photo from the collection of Kenneth Josephson. Bottom photo courtesy of the Burton Historical Collection, Detroit Public Library.)

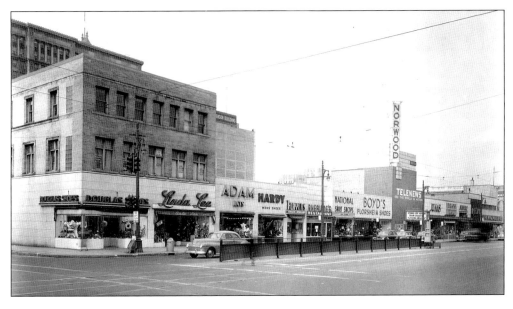

SAKS FIFTH AVENUE. Saks Fifth Avenue opened in the New Center Building in 1940. This luxury department store featured distinctive women's, men's, and children's apparel, as well as domestic and gift items. The store closed its New Center location in the early 1980s. (From the Collection of New Center Council, Inc.)

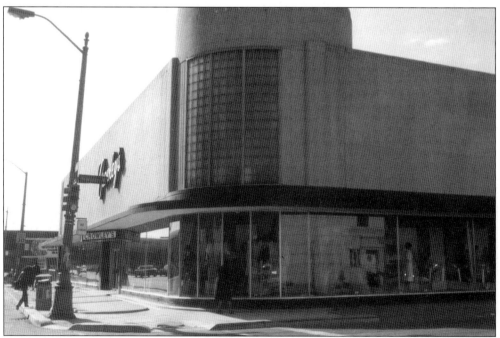

CROWLEY'S. Crowley, Milner and Co. was founded in Detroit in 1895. By the 1980s Crowley's had nine stores, including a store in the former Demery's Department store on Woodward Avenue in New Center. (From the Collection of New Center Council, Inc.)

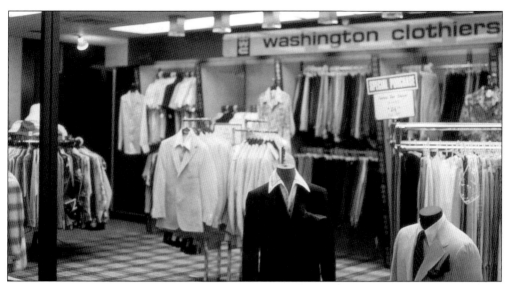

WASHINGTON CLOTHIERS. Albert Kabak took over his family tailor shop in the 1950s and turned it into a men's clothing shop, Washington Clothiers. The original location was downtown on Randolph and later moved to Larned. In the 1960s, another location of Washington Clothiers opened in the General Motors Building, where it remains today. (From the Collection of New Center Council, Inc.)

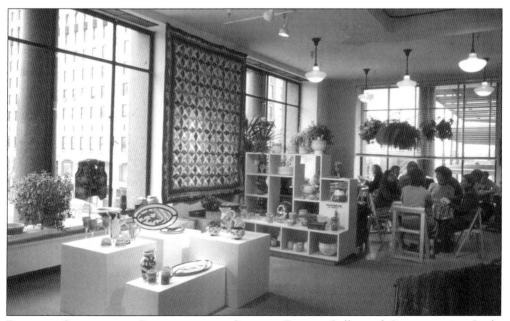

DETROIT GALLERY OF CONTEMPORARY CRAFTS. Detroit Gallery of Contemporary Crafts opened on the third floor of the Fisher Building in 1976. The gallery featured functional ware including pottery, jewelry, quilts, clothing, accessories, dolls, and furniture by leading and emerging craftsmen and was also home to the Garden Cafe, an informal dining spot. The gallery moved to their current location on the first floor of the Fisher Building in 1990 and continues to display the same high-quality crafts that have made them a favorite shopping destination in New Center. (From the Collection of New Center Council, Inc.)

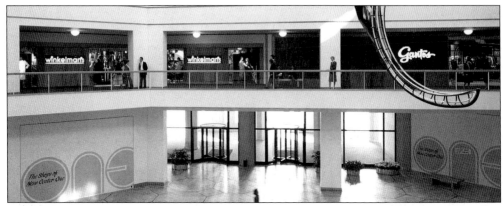

WINKELMAN'S AND GANTOS. Winkelman's and Gantos were two of the first stores to move into the New Center One Building upon its completion in 1983. They were later joined by others, including Crowley's Department Store. (From the Collection of New Center Council, Inc.)

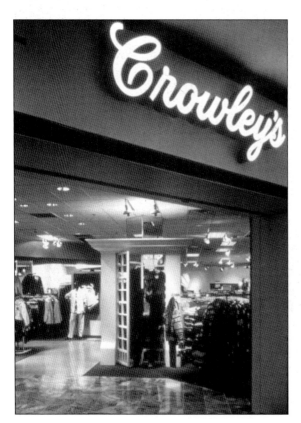

CROWLEY'S. In August of 1985, Crowley's announced that it would move from their Woodward location to the New Center One Building. That move took place on August 18, 1986, with a symbolic "passing of the key" along a human chain from the old store to the new store. The new Crowley's store occupied 45,000 square feet on two levels of New Center One which were connected by an escalator. (Courtesy of the Trizec Real Estate Services, LLC)

PURE DETROIT. Shawn Santo and Kevin Borsay opened their second Pure Detroit store in December of 2001. This "store of all things Detroit," features local topic books, photographs, food products, music in the Pure D Vinyl balcony and Detroit classics like Sanders Hot Fudge, glass bottles of Faygo soda, and their own line of Pure Detroit brand apparel. The store is located in the space formerly occupied by the flower shop in the Fisher Building. (Photograph by Elizabeth Solaka.)

BIZ-R COLLECTION. What started as a small women's boutique in 1994, Biz-R Collection has grown into an elegant 15,000 square foot apparel store featuring women's clothing, shoes, accessories, and hats. The store, which had its grand re-opening in 2002, is located on the second floor of New Center One. (Photograph by Elizabeth Solaka.)

ART DESIGNS GIFT GALLERY. Art Designs Gift Gallery moved into a ground floor retail space in Cadillac Place in June of 2002. The store features jewelry, including co-owner Melesa Plater's signature line, and art for the home and office. (Photograph by Elizabeth Solaka.)

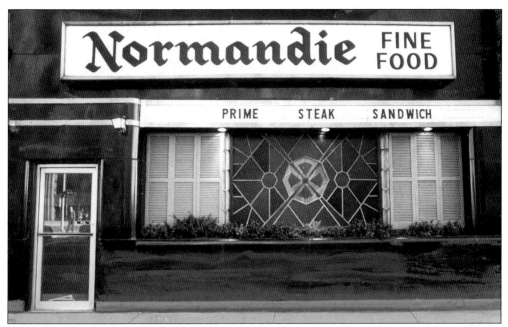

THE NORMANDIE. The Normandie was the place to be seen in Detroit. It was well–known for steaks and chops, and the stream of local and national celebrities that flowed in from the Fisher Theatre across the street. Originally located on Woodward Avenue, the Normandie was moved in 1978 to the Shaw-Walker Building, around the corner on Second Avenue, to make way for a park. (From the Collection of New Center Council, Inc.)

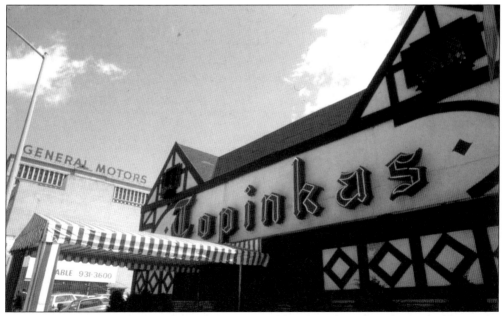

TOPINKA'S ON THE BOULEVARD. Topinka's, famous for its turtle soup and roast duckling in an olde English pub setting, was located on the southeast corner of West Grand Boulevard and Third Avenue. Like the Normandie, it was a favorite spot of Fisher Theatre-goers and performers alike. (From the Collection of New Center Council, Inc.)

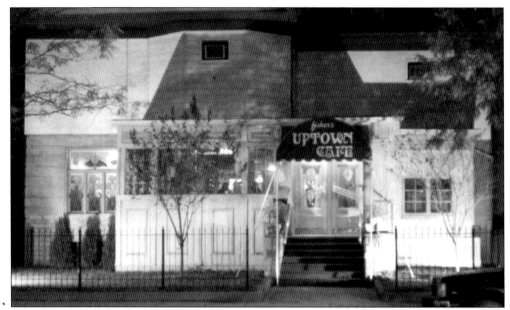

FISHER'S UPTOWN CAFE. The house at 666 Lothrop was built in the late 1880s by Charles Fisher. By 1918 it was no longer a private residence and had become the Uptown Bridge Club. In 1920, Charlie Fisher (no relation to Charles) took over the club and turned it into the first of many restaurants that would occupy the house. In 1986, three partners opened Fisher's Uptown Cafe specializing in continental cuisine. (From the Collection of New Center Council, Inc.)

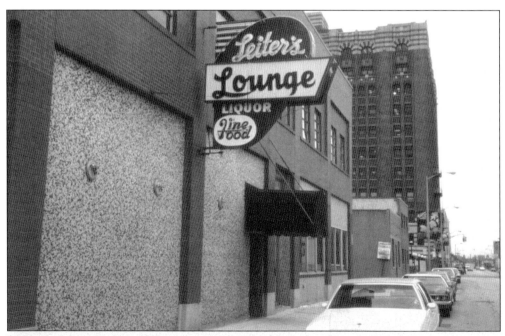

LEITER'S LOUNGE. Leiter's Lounge was famous for its hamburgers. While Leiter's is just a memory, the building has continuously housed a bar and/or restaurant since Leiter's closed. The building has been the home of Hey Jude's and the Tandem Bar. In 2004 it became the Baltimore Bar. (From the Collection of New Center Council, Inc.)

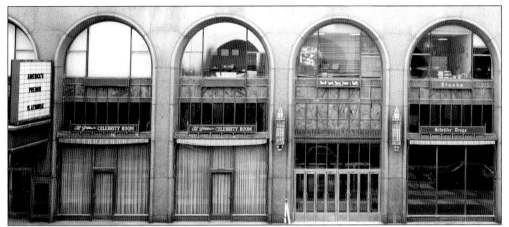

AL GREEN'S CELEBRITY ROOM. Al Green (no relation to the singer) had two restaurants in the historic Fisher Building. Al Green's Celebrity Room was on the main floor and Al Green's Coach Stop was on the concourse level. Fisher Theatre patrons could place their drink orders before the show to ensure their refreshments were waiting for them at intermission. (Courtesy of the Burton Historical Collection, Detroit Public Library.)

MAUNA LOA. The Mauna Loa was next door to the Hotel St. Regis and featured Polynesian food in an exotic setting. The building was torn down to make way for the expansion of the hotel. (From the Collection of New Center Council, Inc.)

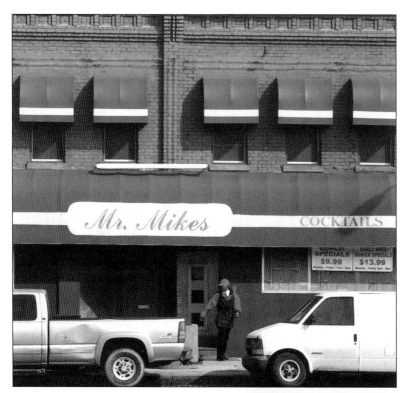

MR. MIKES. Mr. Mikes has been a favorite spot to grab a drink and a great meal for generations. The dark bar and restaurant features deep leather booths and a look that harkens back to the days of three-martini lunches. (Photograph by Elizabeth Solaka.)

WHAT'S ON SECOND? What's on Second? was a popular and friendly dining spot in the late 1980s and early 1990s. Earlier, the space in the Shaw-Walker Building was the home of Terrible Tony's and George's Food and Spirits. (From the Collection of New Center Council, Inc.)

PEGASUS TAVERNA. Expanding on the popularity of Pegasus Taverna in Detroit's Greektown, the owners opened Pegasus in the Fisher Building in 1987, serving lunch to office workers and dinner to patrons on the way to the Fisher Theatre. In the late 1990s, the former manager of Pegasus took over the restaurant, redesigned it with an automotive theme, and renamed it the Motor City Grill. (From the Collection of New Center Council, Inc.)

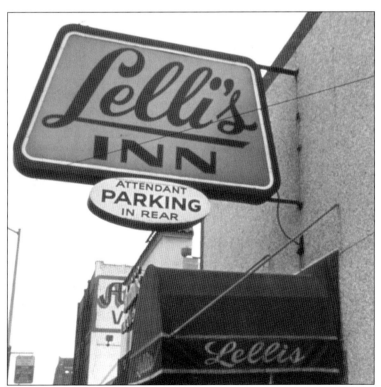

LELLI'S RESTAURANT. Opened in 1939 on Woodward Avenue, just steps from the General Motors Building, Lelli's Restaurant specialized in northern Italian food and was famous for their beef filet with "zip sauce." A second location was opened in the northern suburbs in 1996. A fire in 2000 caused the original Woodward Avenue location to close. (From the Collection of New Center Council, Inc.)

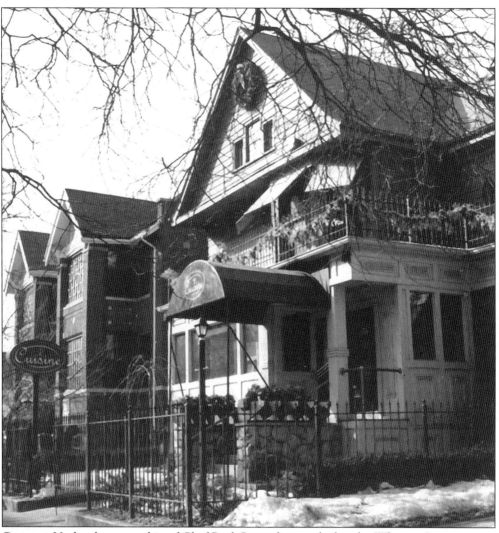

CUISINE. Under the ownership of Chef Paul Grosz, former chef at the Whitney Restaurant in Midtown, Cuisine opened in June of 2001. Cuisine quickly became the home of fine and innovative dining in New Center and was named "Restaurant of the Year" in 2002 by the *Detroit Free Press*. (Photograph by Elizabeth Solaka)

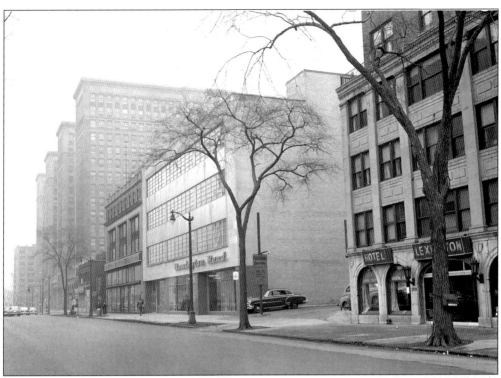

LEXINGTON HOTEL. Located on West Grand Boulevard and Third Avenue next to the Remington-Rand Building, the Lexington Hotel was a fine hotel in its day. Many of the historic photographs of the General Motors and Fisher Buildings were taken from the roof of this hotel. The site of the Lexington Hotel is currently a surface parking lot. (Both photos courtesy of General Motors Media Archive, Copyright 2004.)

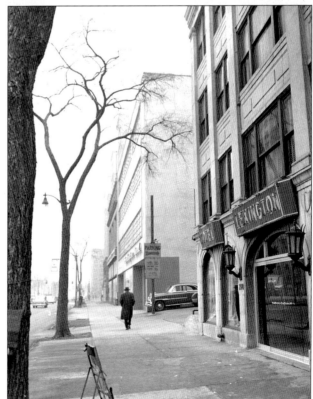

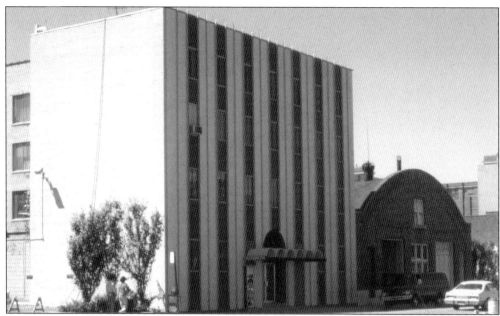

STATE HOTEL. Located at 629 Milwaukee, the State Hotel featured a pool and a bar in the basement. The bar, Bonaparte's Retreat, was a favorite drinking spot of local workers. The hotel is an apartment building today. The building next door, owned by General Motors, was a garage that cleaned and did minor repairs for executives' cars. (From the Collection of New Center Council, Inc.)

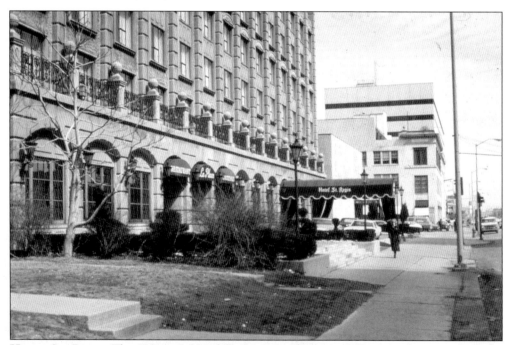

HOTEL ST. REGIS. The 128-room Hotel St. Regis was built in 1967 across the street from the General Motors Building. The St. Regis was a European-style hotel with a small number of rooms and intimate décor. (From the Collection of New Center Council, Inc.)

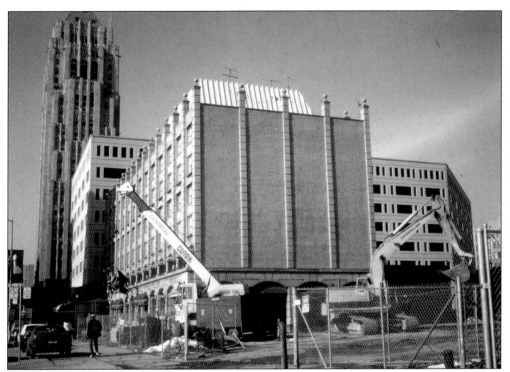

HOTEL ST. REGIS. In 1988, the Hotel St. Regis was expanded to double the size of the quaint, boutique hotel. (From the Collection of New Center Council, Inc.)

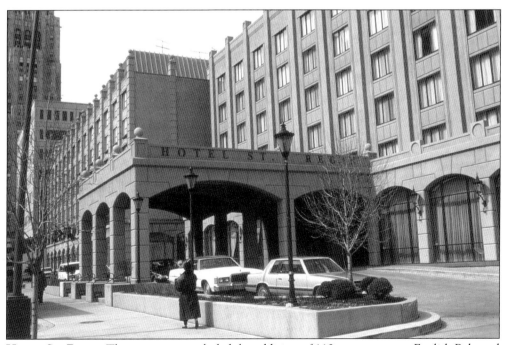

HOTEL ST. REGIS. The expansion included the addition of 112 new rooms, an English Pub, and more meeting and conference space. (From the Collection of New Center Council, Inc.)

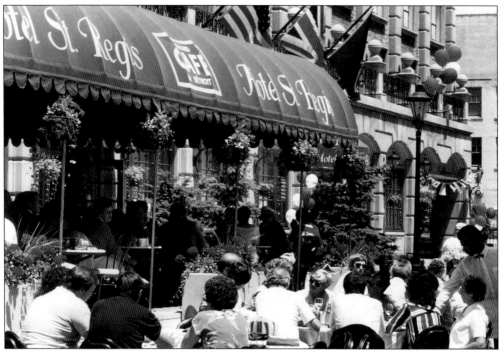

HOTEL ST. REGIS. After the expansion, the St. Regis opened an outdoor patio that featured food and drink, and it became a favorite after-work summertime destination for New Center workers. (From the Collection of New Center Council, Inc.)

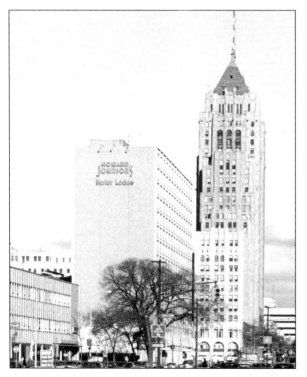

HOWARD JOHNSON'S HOTEL. Howard Johnson's Motor Lodge, located on the Boulevard just west of the Fisher Building, featured 290 rooms and a restaurant. A small movie theatre was also part of the building. In 1971, the hotel was the site of the Vietnam Veterans Against the War's (VVAW) "Winter Soldier Investigation." The three-day event featured over 100 veterans and many civilians describing their horrific war experiences. This event is now considered one of the turning points of the anti-war movement. (From the Collection of New Center Council, Inc.)

Seven

LIVING IN
NEW CENTER

Residential life is the heart of any neighborhood. Before General Motors built their headquarters at West Grand Boulevard and Cass Avenue, New Center was a quiet residential neighborhood. Housing ranged from modest multi-unit apartment buildings for the working class to beautiful single-family homes for Detroit's growing upper class. New Center is now home to two wonderful historic districts: New Center Commons and Virginia Park. These historic homes, in addition to recently constructed townhomes and modern lofts, offer a wide array of options for those wishing to live in New Center.

VIRGINIA PARK/NEW CENTER COMMONS. The most notable residential areas in New Center are found on the northern edge of the district, commonly referred to as New Center Commons and Virginia Park. Virginia Park is on the National Register of Historic Places and New Center Commons, combined with Virginia Park, is a local historic district. The majority of the homes in these districts were constructed between 1895 and 1920. (From the Collection of New Center Council, Inc.)

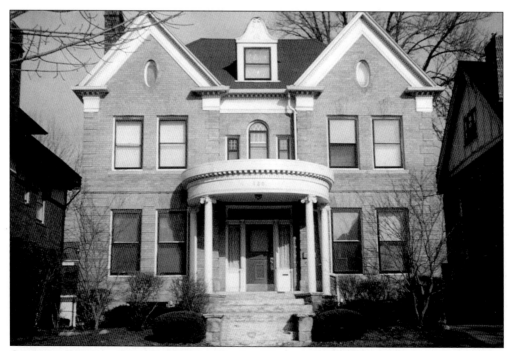

CHARLES WARREN PICKELL HOUSE. Charles Warren Pickell was a well known insurance salesman. He built his Colonial Revival style home in 1895 for the sum of $18,000. (From the Collection of New Center Council, Inc.)

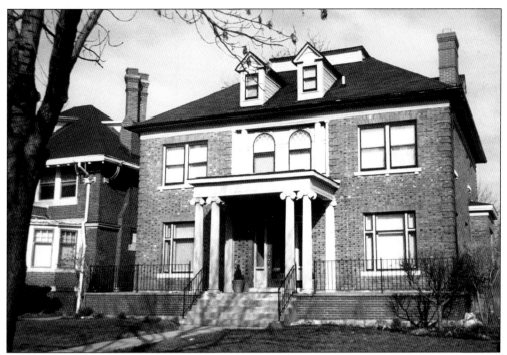

ALBERT H. FINN HOUSE. Albert H. Finn was involved in both publishing and real estate and is credited for helping enlarge the Baptist materials in the Detroit Public Library's Burton Historical Collection. His home, designed in the Colonial Revival style, was built in 1897. (From the Collection of New Center Council, Inc.)

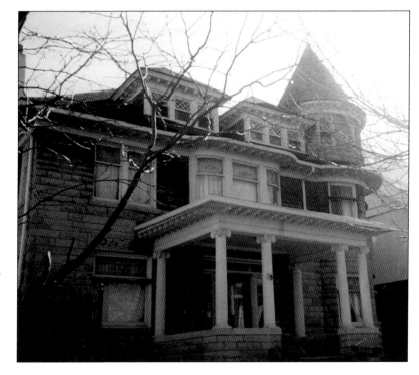

JOHN S. FEE HOUSE. John S. Fee, manager of the Weaver Coal Company, built this Queen Anne/Classical Revival home in 1902. (From the Collection of New Center Council, Inc.)

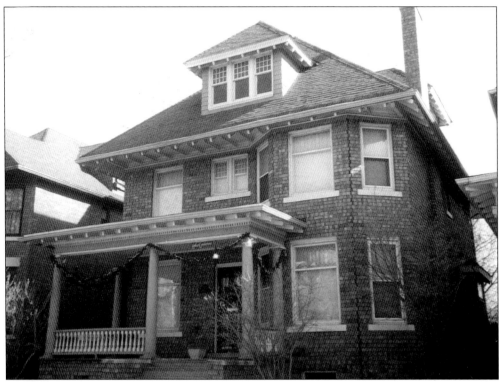

NEUMANN HOUSE. William Neumann, general manager of William F.V. Neumann and Company, built this Colonial Revival house in 1905 for an estimated cost of $4,000. (From the Collection of New Center Council, Inc.)

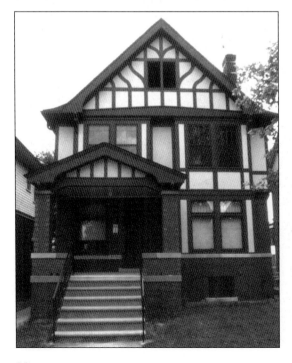

LANGDON HOUSE. Built for an estimated cost of $4,500 in 1907, the architecture firm of Pollmar and Ropes designed the home of Mrs. Emma Langdon. (From the Collection of New Center Council, Inc.)

CHARLES B. VAN DUSEN HOUSE. Charles B. Van Dusen was named president of the S.S. Kresge Company (later to become Kmart) in 1925 after joining the company in 1904. His Neo-Tudor/Arts and Crafts style home was built in 1908. (From the Collection of New Center Council, Inc.)

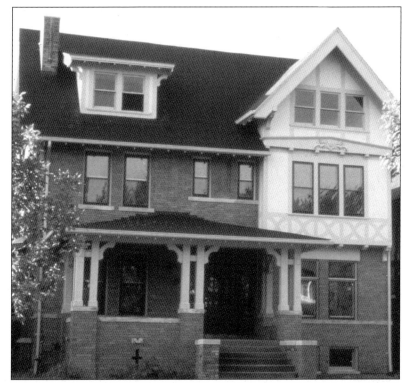

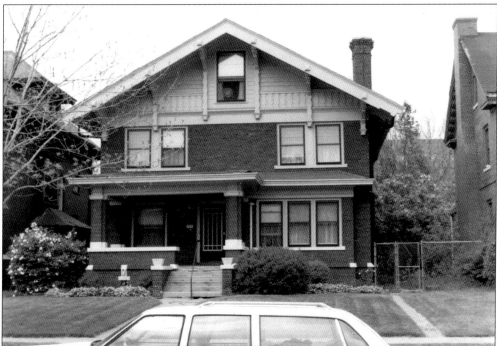

DOUGLAS HOUSE. H.A. Douglas, treasurer and assistant secretary of the Michigan Sugar Company and Minnesota Sugar Company, chose George V. Pottle to design his home. The Arts and Crafts style home was built in 1910. (From the Collection of New Center Council, Inc.)

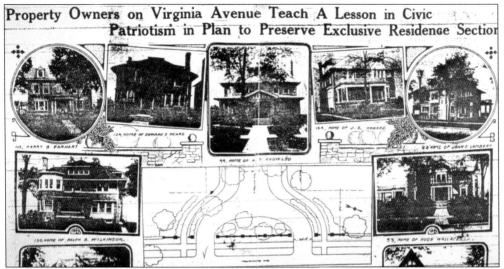

VIRGINIA AVENUE ARTICLE. In 1911, in response to the growing commerical activity on Woodward Avenue, the residents of Virginia Avenue (now Virginia Park) purchased property that faced Woodward Avenue at Hamilton Avenue and constructed an ornamented brick wall of Virginia Colonial design, creating a beautiful entrance to their street. The wall, meant to help secure the residential character of their neighborhood, was designed by architect George V. Pottle. The property was then donated to the city. An article in the *Detroit Free Press* on March 26, 1911, applauded the civic contribution by the Virginia Avenue property owners. (From the Collection of New Center Council, Inc.)

VIRGINIA PARK ENTRANCE. The wall and entrance created by homeowners in 1911 still remains today. It continues to help define the area as one of the premier historic districts in the city. (From the Collection of New Center Council, Inc.)

(*left*) **112 SEWARD.** Besides single-family homes, the area includes many ornate apartment buildings in a variety of architectural styles. The majority of these apartment buildings were constructed between 1915 and 1940. (From the Collection of New Center Council, Inc.) (*right*) **628 DELAWARE.** (From the Collection of New Center Council, Inc.)

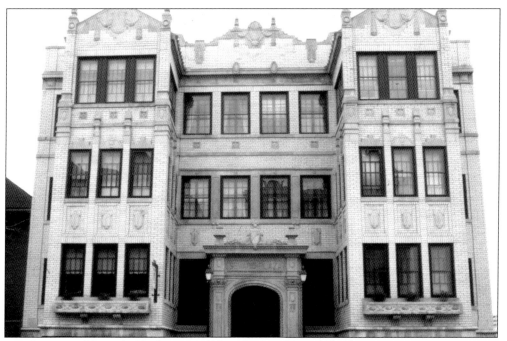

127 SEWARD. (From the Collection of New Center Council, Inc.)

THIRD AVENUE TERRACES. Five townhomes were commissioned by Mrs. Roy Haberkorn for rental property in 1915. (From the Collection of New Center Council, Inc.)

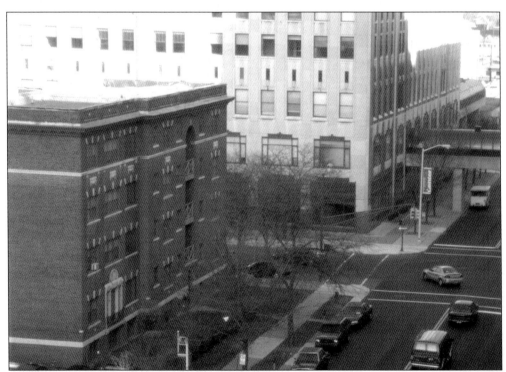

LOTHROP APARTMENTS. The Lothrop Apartments have occupied the corner of Lothrop and Second Avenue since before the Fisher Building was built in 1928. (From the Collection of New Center Council, Inc.)

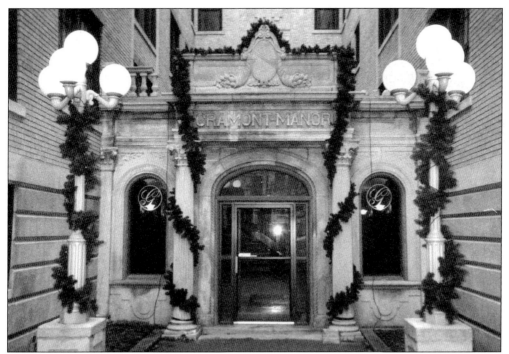

GRAMONT MANOR. The four-story, 49-unit apartment building was constructed in 1923 by Sam Satovsky for $136,000. The units were often rented to businessmen and professionals. (From the Collection of New Center Council, Inc.)

GRAMONT MANOR. In 2000, the Farbman Group renovated the Albert Kahn design building and then converted Gramont Manor into for-sale condominiums. (From the Collection of New Center Council, Inc.)

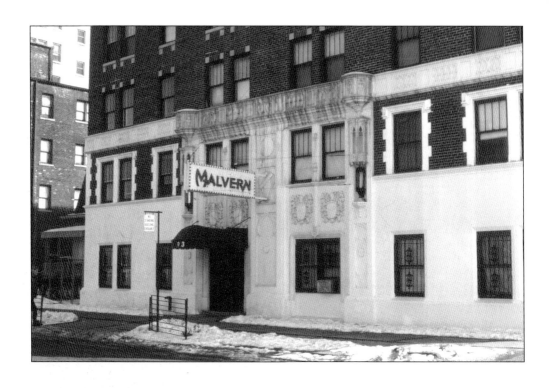

MALVERN/MIDTOWN APARTMENTS.
Goldie Levenstein bought the Malvern in 1974 and managed it through the 1980s. Built in 1927, the Malvern Hotel-Apartments attracted overnight guests looking for a nice place to stay in New Center. The building is now known as the Midtown Apartments. (Both photos from the Collection of New Center Council, Inc.).

NEW CENTER COMMONS

NEW CENTER DEVELOPMENT PARTNERSHIP

General Partner
New Center Community Corporation
(Subsidiary of General Motors Corporation)

Limited Partners
Alexander & Alexander of Michigan, Inc.
American Natural Resources Company
Burroughs Corporation

1001 Services, Inc.
(Subsidiary of First Federal Savings of Detroit)
Detroitbank Corporation
Greenfield Properties, Inc.
(Subsidiary of Ford Motor Company)
Manufacturers National Corporation
Michigan Bell Telephone Company

Campbell-Ewald Company
Detroit Edison Company
Ex-Cell-O Corporation
National Detroit Corporation
J. L. Hudson Company
Trizec Western, Inc.

ADMINISTRATIVE OFFICES SALES OFFICE

NEW CENTER COMMONS. In 1977 General Motors conducted a study of the 18-block area north of their headquarters building in New Center. The area, once a thriving residential district, had fallen on hard times. With the help of 14 partners and the New Center Area Council, GM set about stabilizing the neighborhood. The goal of this stabilization was to renovate as many single family homes as possible and facilitate the development of 200 new units of multi-family mixed-income housing. (From the Collection of New Center Council, Inc.)

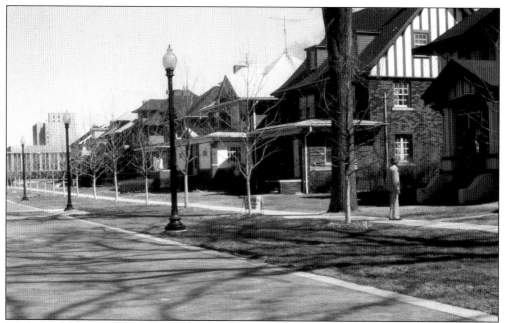

NEW CENTER COMMONS. As a result of the New Center Commons project, 48 single-family homes were renovated and then sold and many multi-family projects were built. In addition to the housing renovations, alleys were widened, new garages were built, guest parking was provided, streets were re-routed and bricked, and a park-like setting was created complete with trees and historic street lights. (From the Collection of New Center Council, Inc.)

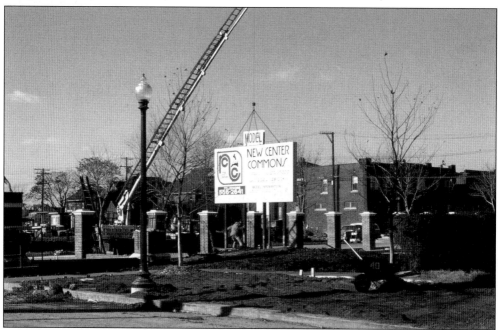

NEW CENTER COMMONS. Additional brick pillars with wrought-iron fencing were added to help define the district. The design of the pillars were matched to the original entrance to Virginia Park. (From the Collection of New Center Council, Inc.)

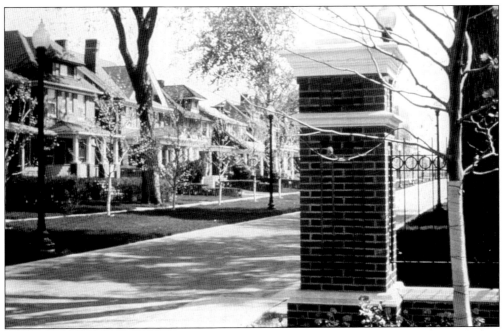

NEW CENTER COMMONS. Deed restrictions were added to the houses that were renovated by GM. The restrictions required the home owners to maintain the historic integrity of the home and also to become members of the neighborhood association that is responsible for maintaining the common areas of the district. (From the Collection of New Center Council, Inc.)

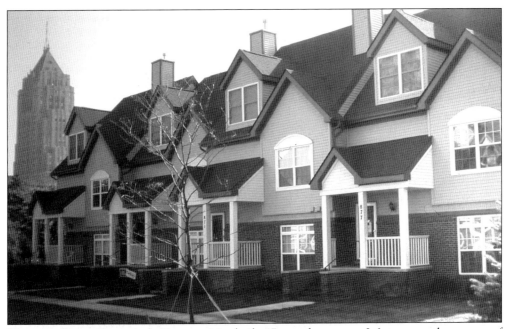

UPTOWN ROW. Crosswinds Communities built 47 townhouses on 3.6 acres on the corner of Lothrop and Third Avenues in 1999. These 1,500-square-foot market-rate condos created a new option for housing in New Center while continuing in the tradition of rebuilding the neighborhood begun by General Motors. (From the Collection of New Center Council, Inc.)

AERIAL SQUARE. Painia Development has completed construction on 12 condominiums, approximately 2,200 square feet each, with prices starting at $160,000. This is the first new construction project to extend beyond the boundary of the GM-led New Center revitalization. (From the Collection of New Center Council, Inc.)

LOFTS AT NEW CENTER. On a 4.4-acre site covering portions of three blocks facing Woodward Avenue between Bethune and Seward Streets, Crosswinds Communities is building 102 new loft-style townhomes. All units are two stories with two-car garages and 1,300 square feet of living space. The façade design is inspired by the rich history of industrial architecture in New Center. (From the Collection of New Center Council, Inc.)

Eight
MUSIC, MEDIA, AND ENTERTAINMENT

From the rich Motown sound to the top-rated radio station, WJR, New Center has witnessed some of Detroit's best music, media, and entertainment. Movies and radio were important to the early days of New Center, while radio is still important most people now associate New Center with Broadway performances at the Fisher Theatre.

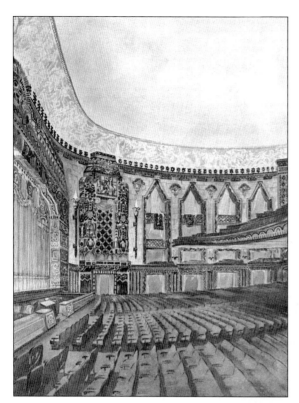

FISHER THEATRE. The Fisher Theatre was originally built as a grand movie palace. Created using a Mayan theme, the theatre included fountains, live birds, and a large pipe organ. While Albert Kahn designed the building, architects A.S. Graven and A.G. Mayger from Chicago were responsible for the 3,000-person theatre. (Courtesy of the Farbman Group.)

FISHER THEATRE OPENING NIGHT PROGRAM BOOK. The theatre opened on Thursday, November 15, 1928, with a very special program. Included in the evening's festivities were performances by the Fisher Symphony Orchestra, special organ performances to show off the amazing *grande* organ, a welcome by Kunsky Theatres Corporation (the operators of the theatre), a newsreel showing a record of the growth of the Fisher Building and, finally, a featured silent film. (Courtesy of the Farbman Group.)

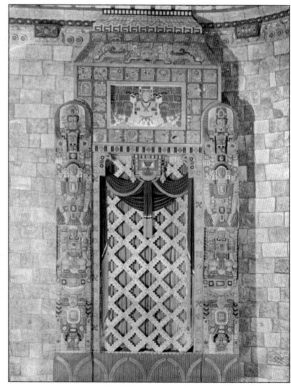

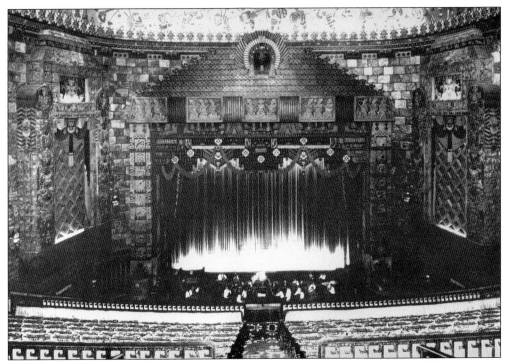

FISHER THEATRE. The Fisher's opening night film was *Outcast*, starring Corinne Griffith and directed by William A. Seiter. (Courtesy of the Farbman Group.)

NEW CENTER NEWS. Founded by William Springer Sr. in 1933 as *New Center This Week* and now known as *Detroit Auto Scene*, this weekly paper is the oldest free newspaper in the United States. The newspaper and its founder helped enforce the idea of the area around the Fisher and General Motors Buildings as "The New Center" and were instrumental in founding the New Center Area Action Council in 1967. (Courtesy of William Springer, Jr.)

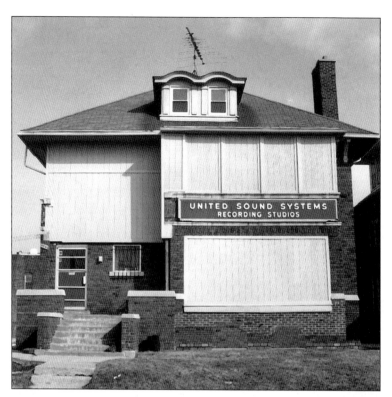

UNITED SOUND. Detroit's first major recording studio, United Sound, was founded in 1933. John Lee Hooker, Jackie Wilson, Marvin Gaye, George Clinton, the Red Hot Chili Peppers, and scores of other Detroit and national luminaries have recorded countless hits at this unassuming building on Second Avenue. (Photograph by Elizabeth Solaka.)

MOTOWN RECORDS. In 1959, Berry Gordy purchased a two-story flat on West Grand Boulevard where he launched Motown Records. The building originally contained his home and the famous "Studio A." From this modest studio, open 24 hours a day from 1959 to 1972, hits were recorded by Motown artists such as Stevie Wonder, the Temptations, the Four Tops, Diana Ross and the Supremes, and Marvin Gaye. The company eventually grew to include eight buildings on West Grand Boulevard before it moved to a high-rise building downtown. (Courtesy of the Motown Historical Museum.)

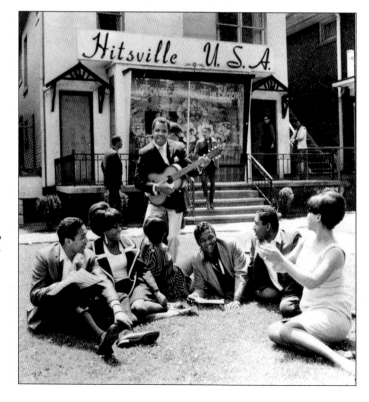

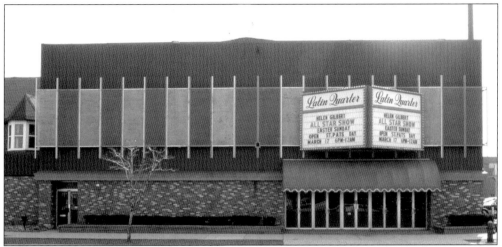

LATIN QUARTER. Built in 1915 as the Duplex Theatre, the building on East Grand Boulevard was redesigned in 1922 into the Oriole Terrace Ballroom by architect C. Howard Crane. Around 1944, the building became the Latin Quarter and featured concerts, banquets, dancing, and other events. In 1956 it was the site of the first National Association for the Advancement of Colored People (NAACP) Freedom Dinner Fundraiser, now one of the largest sit-down fundraising dinners in the country. (From the Collection of New Center Council, Inc.)

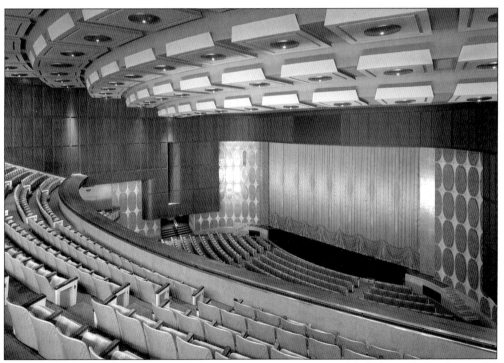

FISHER THEATRE. In 1961, the Neaderlander Company remodeled the Fisher Theatre for Broadway productions. Featuring a design with aspects of Art Nouveau and mid-century Modern, the Fisher Theatre hosts national touring acts of Broadway shows and often is the venue where shows are "tested" before debuting on Broadway. Both *Hello, Dolly!* and *Fiddler on the Roof* staged world premieres at the Fisher Theatre. (From the Collection of New Center Council, Inc.)

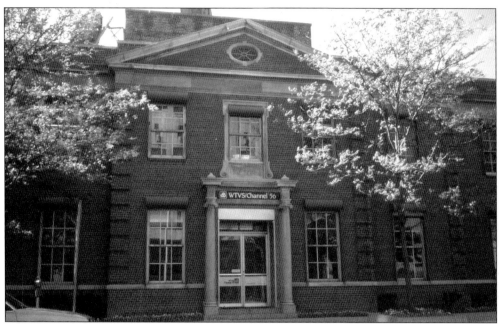

DPTV CHANNEL 56. Begun in 1955 as the third educational TV station to go on the air nationally, WTVS Channel 56 moved from Southfield to its current location in the former WJBK station on Second Avenue in 1971. With the advent of cable and decreased recognition of traditional channel numbers that followed, the station no longer uses Channel 56 to identify itself and now goes by DPTV (Detroit Public Television). (From the Collection of New Center Council, Inc.)

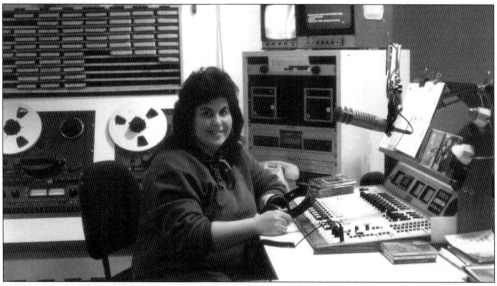

WDET FM 101.9. Before moving to new studios on the south side of campus, WDET-Detroit Public Radio 101.9 FM was located at 6001 Cass Avenue. WDET is the National Public Radio affiliate in Detroit. The building, where their studios were located from 1987 to 1995, is owned by Wayne State University and was once the headquarters to the Cadillac Division of General Motors. (Courtesy of Judy Adams, pictured.)

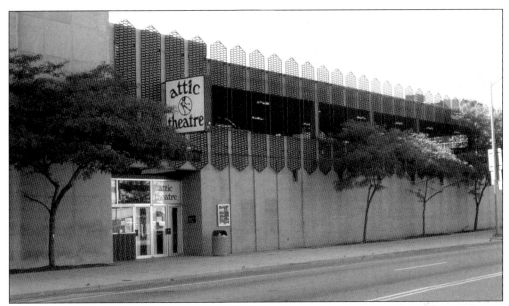

ATTIC THEATRE. After a fire in July of 1984 destroyed the Attic Theatre's Greektown location, the theatre company moved to New Center and occupied the former movie theater in the Howard Johnson's Motor Lodge on West Grand Boulevard. The Attc Theater, a 501(c)3 non-profit organization was Detroit's premier off-Broadway professional theater. (From the Collection of New Center Council, Inc.)

MICHIGAN OPERA THEATRE. The Michigan Opera Theatre was founded in 1973 by Dr. David DiChiera. The MOT moved to New Center from Music Hall in 1985 and began staging their performances at the Fisher Theatre. Offices were located on Second Avenue between West Grand Boulevard and Milwaukee and later on Lothrop. In 1996 the Michigan Opera Theatre bid farewell to New Center and moved to its permanent home at the beautifully renovated Detroit Opera House in downtown Detroit. (From the Collection of New Center Council, Inc.)

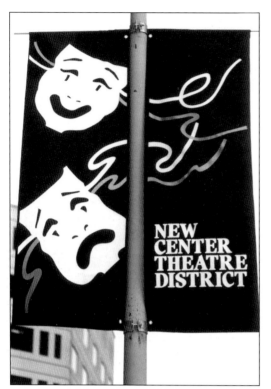

THEATRE DISTRICT BANNERS. With the addition of the Attic Theatre to the neighborhood, joining the Fisher Theatre and the Michigan Opera Theatre, New Center became a destination for top-quality entertainment. The New Center Theatre district was celebrated with street banners and opening night events. (From the Collection of New Center Council, Inc.)

WJR RADIO. Broadcasting from the "golden tower of the Fisher Building," in 1928, WJR became the first tenant of the Fisher Building. At the time, the station was owned by G.A. Richards, who also owned a Pontiac Oakland dealership in the nearby Argonaut Building. WJR has maintained its commitment to the Fisher Building and New Center and still calls the historic landmark home. (From the Collection of New Center Council, Inc.)

WJZZ. WJZZ-FM was Detroit's long-time all-jazz radio station. The station was located on East Grand Boulevard and, in 1996, over loud protests from jazz purists, it switched formats. (From the Collection of New Center Council, Inc.)

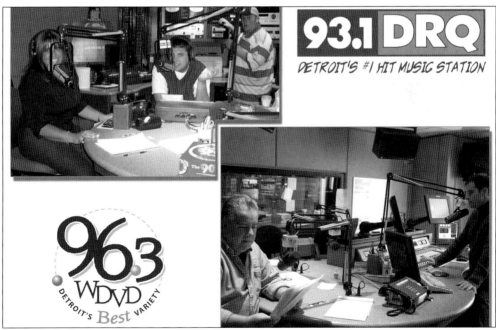

WDVD/WDRQ. While WJR is broadcast on AM radio, its sister stations WDVD and WDRQ are broadcast from the Fisher Building on the FM dial. Morning shows are an important tradition in Detroit, and in this spirit, 93.1 DRQ features "Jay and Rachael in the Morning" and 96.3 WDVD has the "96.3 WDVD Morning Show with Blaine Fowler." (Courtesy of Mary Santos.)

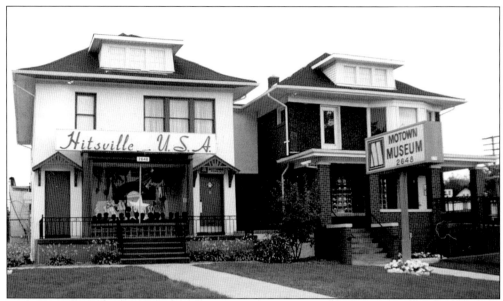

MOTOWN MUSEUM. Founded in 1985 by Esther Gordy Edwards, sister of Motown Records founder Berry Gordy, the Motown Historical Museum is located in the house where Motown Records got its start. The museum features exhibits that trace the story of Motown Records from its founding in 1959 to its international success and importance in 20th-century musical history and popular culture. Thousands of visitors from around the world are attracted to the Motown Historical Museum and regularly make long pilgrimages to witness the presentation of the "Motown Sound" legacy. (Courtesy of the Motown Historical Museum.)

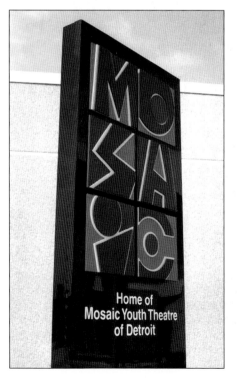

MOSAIC YOUTH THEATRE. Founded in 1992, the Mosaic Youth Theater is a multicultural arts organization whose mission is to develop young performing artists through comprehensive theatrical and musical training and to provide high quality performances for audiences of all ages. The Mosaic Youth Theatre found a permanent home for their award-winning programs in the recently constructed University Prep High School. Their new space features administrative offices, a choral room, a wood shop for set construction, and a "black box" theatre called the "General Motors Mosaic Youth Theatre" for performances. (Photograph by Elizabeth Solaka.)

Nine
TasteFest and Other Events

From the ceremony that marked the ground breaking of the Detroit General Hospital (later to become Henry Ford Hospital in 1912) to the massive Comerica TasteFest in 2003, New Center knows how to throw a party. Since the founding of the New Center Area Action Council in 1967 (later the New Center Area Council and now New Center Council, Inc.), special events have become a tradition and hallmark of the neighborhood. Whether held to raise money for a worthy cause, promote awareness of the great neighborhoods, or just to have a good time, New Center's history is rich with special events.

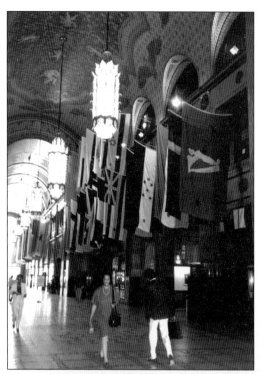

LOBBY FLAGS. In 1970, a box of flags was discovered in a closed-off room in the Fisher Building. The flags represented all the countries of the world at the time the Fisher Building was completed in 1928. Since their discovery, the flags are hung each year in the lobby. Many of the countries represented no longer exist. (From the Collection of New Center Council, Inc.)

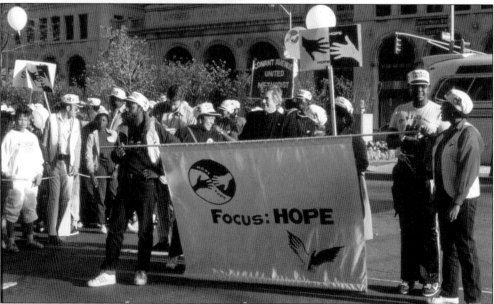

FOCUS HOPE WALK FOR JUSTICE. Focus: HOPE is a nationally recognized civil and human rights organization in Detroit, Michigan. Their mission is to use intelligent and practical action to fight racism, poverty, and injustice. Since 1975, Focus: HOPE has conducted an annual walk through the streets of Detroit, modeled after marches led by Dr. Martin Luther King Jr. to raise awareness about the social and economic problems that still exist in our society. Although the walk now begins and ends at their campus north of New Center, for a number of years the walk route passed through the streets of New Center. (From the Collection of New Center Council, Inc.)

ANNUAL KITE SHOW & DISPLAY. For many years New Center Area Council co-sponsored a display of kites in the lobby of the Fisher Building to celebrate the arrival of spring. (From the Collection of New Center Council, Inc.)

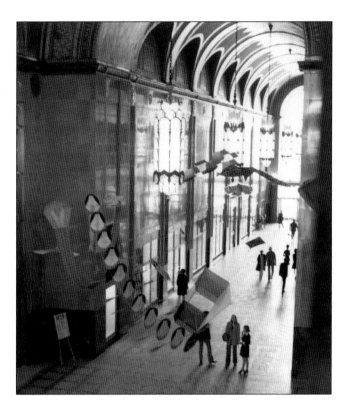

EMILY AND POOH 10K FUN RUN. New Center was the finish line for the Emily and Pooh 10K Fun Run in 1982. The race began downtown on the roof of Cobo Hall, passed through Tiger Stadium, came down Cass Avenue past Wayne State University and ended under the recently completed skywalk that connects New Center One to the GM Building. Emily Gail owned Emily's, a sundry and gift shop, on Congress downtown and was a well-known promoter of the city of Detroit who coined "Say Nice Things About Detroit." (Courtesy of the Trizec Real Estate Services, LLC.)

BED RACES. To benefit the Muscular Dystrophy Association, annual bed races were held along West Grand Boulevard. A different take on bobsled racing, teams from area businesses and organizations were provided hospital beds as race vehicles. Beds were decorated and raced with a five person team, four pushing and one person riding along. (Courtesy of the Trizec Real Estate Services, LLC.)

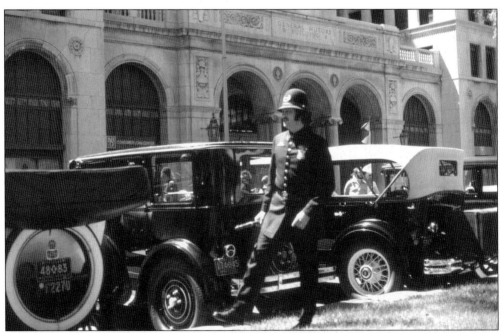

WHEELS OF FREEDOM ANTIQUE CAR SHOW. Conceived by local car collector Richard Kughn, the Wheels of Freedom Antique Auto Show & Parade was part of the annual Detroit Windsor International Freedom Festival. Over 200 cars, covering the complete history of the automobile, were displayed along West Grand Boulevard after they made their way across the Ambassador Bridge from Canada. (From the Collection of New Center Council, Inc.)

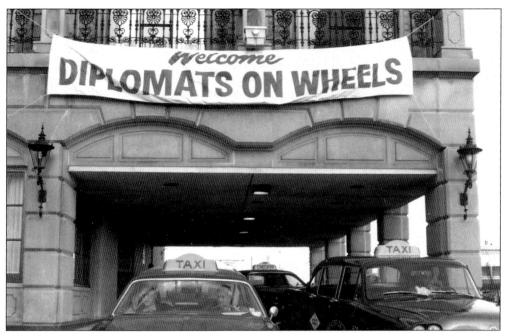

DIPLOMATS ON WHEELS. A visitor's first impression of a city is often formed during an introductory cab ride. Recognizing this, the Hotel St. Regis hosted a "Diplomats on Wheels" breakfast to let Detroit "cabbies" know how important they are to the visitor experience. (From the Collection of New Center Council, Inc.)

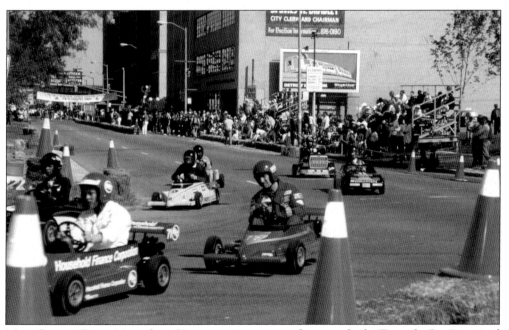

MINI GRAND PRIX. More than 50 companies sponsored custom-built "Formula One" inspired cars as part of the New Center Lions Club annual Mini Grand Prix. This race, through the streets of New Center, always featured local celebrities and an enthusiastic crowd. This event was held from 1985 through 1997. (Courtesy of the Trizec Real Estate Services, LLC.)

UNCF WALK-A-THON. In 1989, the United Negro College Fund (UNCF) held their first indoor Walk-A-Thon through the Fisher, Albert Kahn, New Center One, and General Motors Buildings using the underground tunnels and skywalks that connect the buildings. (Courtesy of Jackie Vaughn.)

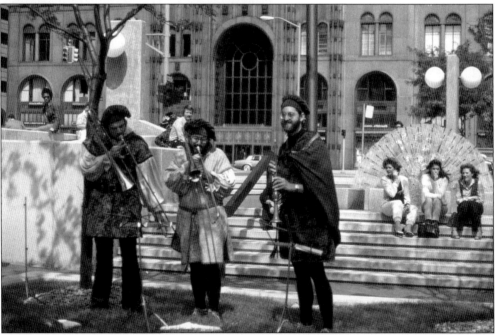

MICHIGAN RENAISSANCE FESTIVAL. To promote the annual Michigan Renaissance Festival in Holly, festival performers would parade through the office buildings of New Center and, upon reaching New Center Park, would present highlights of the upcoming festival. This event was coordinated through the New Center Area Council. (From the Collection of New Center Council, Inc.)

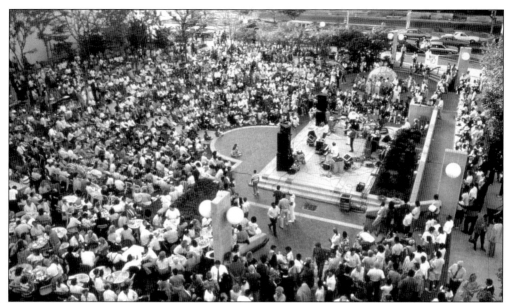

CONCERTS IN THE PARK. In the late 1970s, General Motors built a small "pocket park" at the corner of Second Avenue and West Grand Boulevard, just west of the GM Building. For many years, the New Center Area Council produced lunchtime and evening concerts in the park, which featured performers ranging from Maynard Ferguson to local favorites like the Contours and Alexander Zonjic. Food and drink were served by the restaurants that bordered the park. (From the Collection of New Center Council, Inc.)

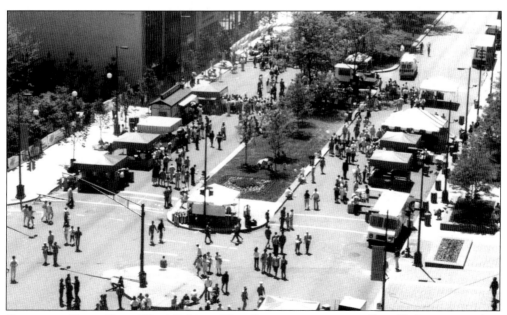

COMERICA TASTEFEST. The Michigan TasteFest, as it was originally called, was started in 1989 by the New Center Area Council. Originally held during Memorial Day weekend throughout the streets of New Center, the event featured tastings from some of Detroit's finest restaurants as well as entertainment for visitors both young and old. (From the Collection of New Center Council, Inc.)

NEW CENTER GREAT PUMPKIN CARVE-UP.
New Center companies submitted entries to
the annual Great Pumpkin Carve-Up. The
historic buildings in New Center, including
the landmark Fisher Building, served as the
inspiration for the entry by Trizec Properties,
Inc. (Courtesy of the Trizec Real Estate
Services, LLC.)

HOLIDAY LIGHTING. Another long-standing
tradition in New Center is the annual
lighting program that adorns the trees
throughout the district from November to
January. Anticipated by visitors, residents,
and employees alike, the holiday lights are
produced by the New Center Council. For
many years a ceremony was held to kick off
the holiday season by turning on the lights.
From the skywalk above West Grand
Boulevard, Santa would throw the switch
and like magic the Boulevard and
surrounding area would be warmed by the
glow of dozens of trees covered in holiday
lights. (From the Collection of New Center
Council, Inc.)

MIRACLE ON THE BOULEVARD. Started by the Hotel St. Regis and advertising firm Lovio-George, and eventually taken over by New Center Area Council, "Miracle on the Boulevard" collected needed items including toys, clothing, food, and toiletries for residents of 12 Detroit-area shelters during the holidays. Donations were collected from area businesses and at the Miracle on the Boulevard drop box which was located in the lobby of New Center One. (From the Collection of New Center Council, Inc.)

WJR SING-A-LONG. For many years, WJR held their annual holiday sing-along in New Center Park. The event, held in the evening, featured WJR celebrities and friends and never failed to spread the holiday spirit. (From the Collection of New Center Council, Inc.)

HOOP IT UP. In 1989, New Center Area Council sponsored a three-on-three basketball tournament on the Boulevard. Teams of all ages, both men and women, competed for New Center basketball bragging rights. (From the Collection of New Center Council, Inc.)

BEACH PARTY VOLLEYBALL. Jose Cuervo brought its Amateur Beach Volley Ball tour to New Center in 1992. A "beach" was created with the delivery of sand to Second Avenue, and amateurs competed for fun and prizes. The event was sponsored by the New Center Area Council and proceeds from registrations went to the New Center Foundation. (From the Collection of New Center Council, Inc.)

WJR/J.P. McCarthy St. Patrick's Day Party. WJR morning show host and Detroit legend, J.P. McCarthy (left), hosted an annual broadcast and party to celebrate St. Patrick's Day in the lobby of the Fisher Theatre. The popular event was attended by hundreds of the State's best-known celebrities and dignitaries. While J.P. McCarthy passed away in August of 1995, the event still continues, led by J.P.'s successor, Paul W. Smith. (From the Collection of New Center Council, Inc.)

Swingtime. Swingtime, held in the lobby of the Fisher Building each year since 1999, is the signature event of the Fanclub Arts Foundation. This swing-era themed party features food and drink from area restaurants, a silent auction, an exhibit by local artists, and dancing to swing music. Money raised at this and other Fanclub events supports arts education in southeast Michigan. (Courtesy of Fanclub Arts Foundation)

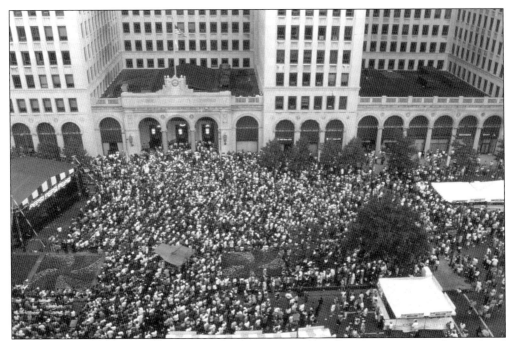

COMERICA TASTEFEST. The four stages at the Comerica TasteFest feature the very best in local and national entertainment and help draw the crowds to New Center for this annual event. Past performers on the main stage have included Issac Hayes, Joan Jett, Collective Soul, Ziggy Marley, Billy Preston, Los Lobos, Tweet, Wilco, and Ramsey Lewis, to name a few. (From the Collection of New Center Council, Inc.)

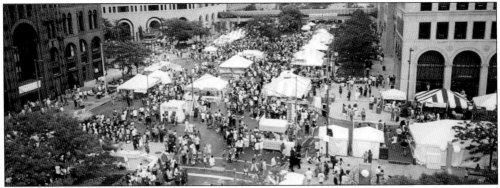

COMERICA TASTEFEST. The Comerica TasteFest, as it is now known, has grown into one of the premier outdoor festivals in Metro Detroit. What started out as a small street fair has grown into a regional attraction for over 400,000 people each year. Now held for five days over the Fourth of July holiday, the Comerica TasteFest features over 40 restaurants, four stages featuring local and national musicians, a street market specializing in unique merchandise, two areas for the younger visitors, and more. (From the Collection of New Center Council, Inc.)

Ten
RECENT DEVELOPMENTS AND FUTURE PLANS

The future of New Center is bright. The wonderful combination of new construction and renovation of historic buildings in New Center rivals any urban district in the Metro Area. New Center has at its core, a strong infrastructure of wonderful buildings and attractions. When combined with creative energy and the goal of a 24-hour mixed-use neighborhood, great things are sure to follow.

DPS Children's Museum. In 2001, the Detroit Public School's Children's Museum moved to this renovated former Detroit Edison substation from its long-time home in the Cultural Center. The chrome horse that stands in front, and has become a symbol of the museum, is made from automobile bumpers. The horse originally stood in front of the former location and thankfully made the move along with the museum. (Photograph by Elizabeth Solaka.)

DPS Welcome Center. In 2002 Detroit Public Schools announced that they would move from their long-time Cultural Center headquarters to New Center. Their new offices in New Center includes four floors of the historic Fisher Building and a Welcome Center in the former Crowley's space in the New Center One Building. (Courtesy of Detroit Public Schools.)

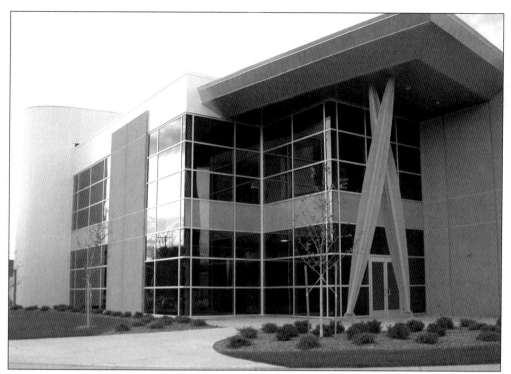

UNIVERSITY PREP HIGH SCHOOL. Built with a grant by local education philanthropist Robert Thompson, the University Preparatory High School is a charter school under the direction of former State Senator Doug Ross. The campus includes four education buildings where students work in small classes, and a central building that houses a gymnasium, work-out room, and the Mosaic Youth Theatre of Detroit. (From the Collection of New Center Council, Inc.)

CASS BLOCK. New Center Council plans to partner with a private developer to acquire the land on Cass Avenue in "TechTown" to construct 28 new townhomes and loft-style residential condominiums and over 6,000 square feet of retail space. (Courtesy of studioZONE.)

PROPOSAL EAST FACADE IMPROVEMENTS
BETWEEN MILWAUKEE AND BALTIMORE

PROPOSAL EAST FACADE IMPROVEMENTS
BETWEEN GRAND BOULEVARD AND MILWAUKEE

ALLEN & LAUX

PHASE I STREETSCAPE PLAN

ZACHARY & ASSOCIATES, INC

JANUARY 14, 1999
NEW CENTER GATEWAY
DETROIT, MICHIGAN

WOODWARD GATEWAY. In an effort to compete with suburban malls, a canopy was added to both sides of the Woodward Avenue shopping district between Grand Boulevard and Baltimore Avenue in the 1970s. In August of 2000, New Center Council received a grant from the State of Michigan to remove the canopies and install new street trees, historic lighting, new pavers, benches, and trash receptacles. Designed by Albert Kahn Associates, Inc., the new street scapes are expected to begin in the spring of 2004. (From the Collection of New Center Council, Inc.)

YOUTHVILLE. YouthVille Detroit, a project of the Detroit Youth Foundation, will house a specially-designed center for young people aged 11–19 in the former home of Allied Video on the corner of Woodward Avenue and Lothrop. The center will help young people learn new skills and develop positive peer and adult relationships in a safe neighborhood environment. The building will also house 10 additional youth and family service agencies under one roof. (Courtesy of Detroit Youth Foundation.)

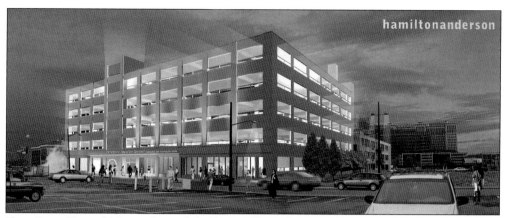

TechOne. General Motors donated the former Chevy Creative Services Building to Wayne State University for phase one of the WSU Research & Technology Park, "TechTown." The historic building at 440 Burroughs, now referred to as "TechOne," will offer incubation space for upstart technology companies and will house the TechTown staff. (Courtesy of Wayne State University.)

NextEnergy. In December of 2002, ground was broken for the 40,000-square-foot NextEnergy Center on Second Avenue between York and Burroughs. A initiative of the State of Michigan, the NextEnergy Center will offer educational programs in power electronics and will endeavor to design and create alternative energy enabling technologies including fuel cell technology. Additionally, the Center will provide laboratory space and business incubator space for alternative energy companies. (Courtesy of NextEnergy.)

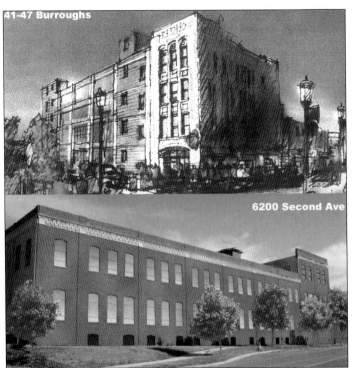

41–47 Burroughs

6200 Second Ave

41–47 BURROUGHS/6200 SECOND AVENUE. Together, the Graphic Arts Building and the Century Florist Supply (Caille Brothers Building), will be renovated into 89 rental loft-apartments. The creation of loft units in this once-industrial neighborhood will help further the creation of a 24-hour mixed-use urban neighborhood. (From the Collection of New Center Council, Inc.)

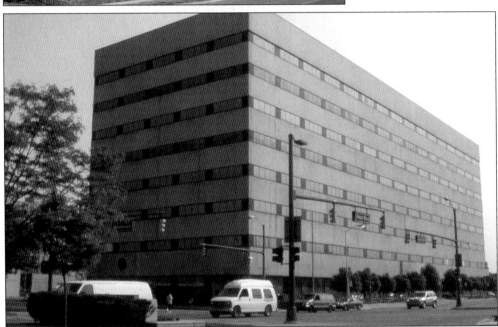

MESA BUILDING. New Center Council is currently working with several area stakeholders to explore the possibility of securing this historic building from the State of Michigan, and converting it from commercial space to 150 residential rental apartments with retail on the ground floor. As part of the renovation, the "modernization" that occurred on the southern and western elevations in the 1960s, will be reversed by applying replicated panels of the original terra cotta façade. (From the Collection of New Center Council, Inc.)